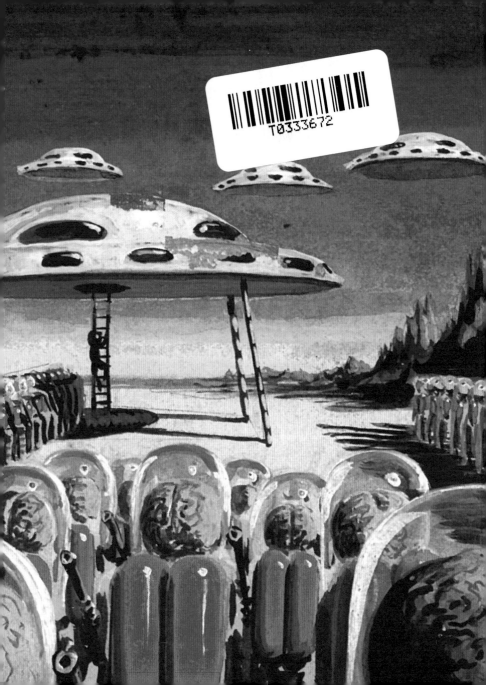

MARS ATTACKS

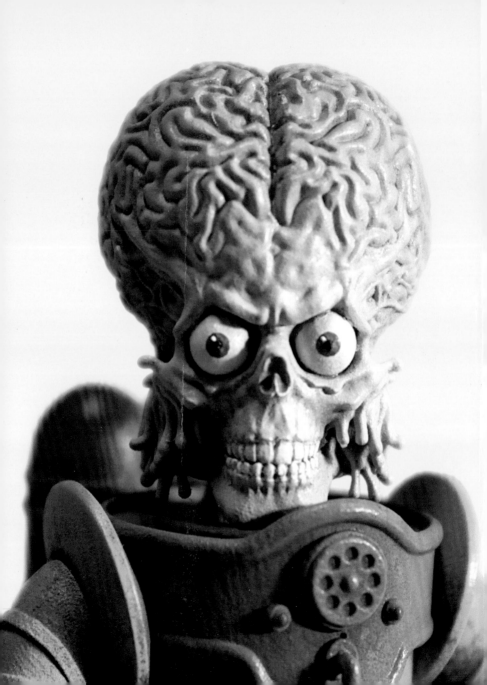

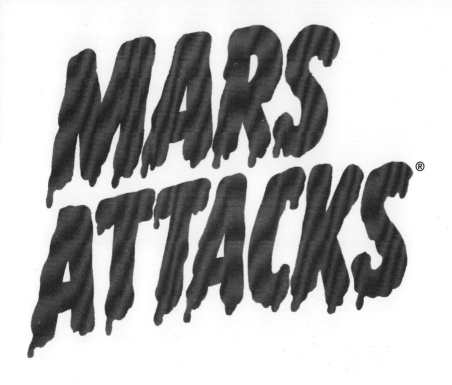

By The Topps Company, Inc.

Introduction and commentary by Len Brown
Afterword by Zina Saunders

Abrams ComicArts, New York

TO WOODY, LEN, WALLY, BOB, AND NORM

ACKNOWLEDGMENTS: Thanks to Ira Friedman and Adam Levine at Topps; Len Brown and Zina Saunders for their editorial contributions, as well as for their generosity and all-around availability to help this book come together; Fred Walstrom (for very generously supplying us with rare images from his collection); Grant Geissman (advice and friendship); Les Davis (for letting us quote from Butch Capadagli's 1981 interview with Norm Saunders published in *The Wrapper*). At Abrams ComicArts: Charles Kochman (editorial), Kari Pearson (editorial assistance), Sara Corbett (design), Chad Beckerman (art direction), David Blatty (managing editorial), and Alison Gervais (production). Finally, a very special thank-you to Woody Gelman, Len Brown, Wally Wood, Bob Powell, and Norm Saunders for the creation of this material.

Editor: Charles Kochman
Designer: Sara Corbett
Production Manager: Alison Gervais

Library of Congress Cataloging-in-Publication Data:

Mars attacks / by the Topps Company, Inc. ;
Introduction by Len Brown ; afterword by Zina Saunders.
 p. cm.
 ISBN 978-1-4197-0409-3
1. Trading cards. 2. Mars attacks I. Topps Chewing Gum, Inc.
 NC1002.C4M36 2012
 741.6—dc23

 2012001737

Copyright © 2012 The Topps Company, Inc.
Introduction copyright © 2012 Len Brown
Afterword and accompanying photographs copyright
 © 2012 Zina Saunders
Mars Attacks and Topps are registered trademarks
 of The Topps Company, Inc. All rights reserved.

Printed in Hong Kong
15 14 13 12 11

Abrams ComicArts books are available at special discounts when purchased in quantity for premiums and promotions as well as fundraising or educational use. Special editions can also be created to specification. For details, contact specialsales@abramsbooks.com or the address below.

ABRAMS The Art of Books
195 Broadway, New York, NY 10007
abramsbooks.com

Cover design by Sara Corbett
Case photography by Geoff Spear

Page ii: Detail of Mars Attacks action figure, 2012, courtesy of Mezco Toys. Sculpted by Steve Kiwus.
Page 9: *Weird Science* no. 16 (November–December 1952), illustrated by Wally Wood. Copyright © E .C. Comics/William M. Gaines Agent, Inc.
Page 9: *This Island Earth* movie poster and photograph copyright © 1955, Universal Pictures International.
Page 10: *Mars Attacks* movie poster copyright © 1996, Warner Bros.

All of the images of "The Classic 55" were scanned from original transparencies and trading cards in the Topps archives. Every effort was made to keep the quality of images consistent throughout this book.

Interview with Len Brown (captions, pages 13–119) conducted by Adam Levine on January 14, 2012.

The following artists contributed to the "Visions: New and Original" section of this book as well as "The World of Mars Attacks" (numbers refer to pages):

Charlie Adlard (144), **Kevin Altieri** (145), **Simon Bisley** (146), **Steve Bissette** (173), **John Bolton** (147), **Ted Boonthanakit** (137, 138), **Frank Brunner** (148), **Mark Chiarello** (149), **Joe Ciardiello** (150), **Geof Darrow** (151), **Ricardo Delgado** (152), **Cathy Diefendorf** (175), **Jim Elliot** (176), **Steve Fastner** (153), **Drew Friedman** (141), **John G. Gernon** (172), **Keith Giffen** (134, 135, 154), **Jim Groman** (174), **Sam Kieth** (155), **Miran Kim** (156), **Gus LaMonica** (177), **Rich Larsen** (153), **Jay Lynch** (167, 178, 179), **Earl Norem** (123–33, 139, 140), **Michael Ploog** (157), **John Pound** (143), **Ed Repka** (170, 171), **John Rheaume** (158), **Rob Robison** (168), **Chris Ryan** (169), **Norm Saunders** (166), **Zina Saunders** (122, 142, 159, 178, 179), **Peter Scanlan** (180), **Mark Schultz** (160), **Joe Smith** (161), **Ken Steacy** (136, 162, 181), **William Stout** (163), **Herb Trimpe** (123–33), **Timothy Truman** (164), and **John Van Fleet** (165).

www.topps.com

MARS ATTACKS!

MARTIAN DAYS—IN THE BEGINNING

by LEN BROWN

On a spring day in 1955, I was thirteen years old and riding a bus in Brooklyn when I saw something that was life changing for me! At a red light, I stared out the window at a newsstand with a new magazine on display—issue number one of a publication "for boys" by Triple Nickel Books. The cover featured a man in a coonskin hat carrying a rifle through the woods, completely oblivious to a menacing Indian stalking him from behind. It was an adventure magazine featuring a biography of the American frontier hero Davy Crockett.

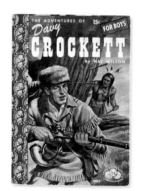

At the time, Crockett was a national rage, thanks to a Walt Disney television series, and kids across America were all singing the number one hit "The Ballad of Davy Crockett" by Bill Hayes, collecting Crockett trading cards, and dressing like their TV hero. At home I kept thinking about the magazine I had seen, and the following morning I decided to walk the two miles back to the newsstand and purchase it. I had no way of knowing that the events of that day would ultimately have a lasting effect upon my life.

TOP: Cover for *The Adventures of Davy Crockett* by Nat Wilson. Triple Nickel Books no. 1 (1955), published by Woody Gelman. **BOTTOM:** Soupy Sales with Len Brown (left) and Woody Gelman (right), taken in 1967 at the time Topps released a series of "wallet-size" photo trading cards of the television personality.

I read the Crockett biography quickly, wrote a letter to an unknown editor praising this new boys' publication, and just a few days later, received a surprise phone call. It was from Woody Gelman, the publisher of Triple Nickel Books and also the creative director for Topps Chewing Gum, Inc. in Brooklyn. In his position at Topps, Woody was the person who planned and created which trading card series Topps would release. Ever since my sixth birthday, I had been spending my pennies on the various trading card packages that Topps marketed in the late 1940s and early '50s.

Picture cards like Scoop (a series chronicling world history), Jets (modern airplanes), Freedom's War (Korean War cards), Target Moon and Spacemen (two early sets that focused on outer space and science fiction), and of course, the annual baseball cards were all typical of the Topps products I collected back in my preteen days.

When Woody invited me to visit the Topps offices, I was overjoyed. I remember walking down 36th Street in Brooklyn for the first time and

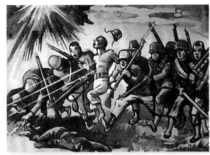

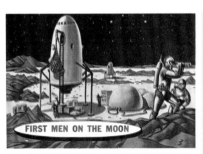

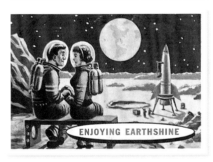

LEFT TO RIGHT, TOP TO BOTTOM: Scoop (1954) no. 72, "Ederle Swims Channel" and Scoop no. 75, "Dillinger Shot"; Jets (1956) no. 116, "Convair YF-102" and Freedom's War (1950) no. 28, "They Won't Stop!"; Target Moon (1957) no. 33, "First Men on the Moon" and Target Moon no. 50, "Enjoying Earthshine"; Spacemen (1951) no. 175, "Overcoming Pirate Rocket."

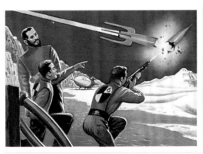

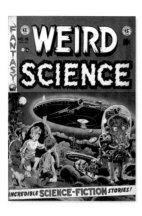 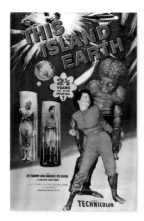 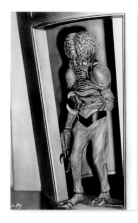

LEFT: *Weird Science* no. 16 (November–December 1952), illustrated by Wally Wood. This classic E.C. Comics cover prompted Gelman and Brown to contact Wood as the first artist hired to visualize their series concept. **MIDDLE AND RIGHT:** Movie poster and publicity photo for *This Island Earth*, released by Universal Pictures International (1955). According to Len Brown, the mutant aliens were one of the primary inspirations for the look and design of the Martians in Mars Attacks.

smelling the aroma of Bazooka Bubble Gum as I approached Topps. I really could taste sugar on my tongue, as it permeated the air outside the factory at 254 36th Street, where the gum was manufactured.

For five years after that first visit, I maintained a telephone friendship with Woody Gelman, as he became almost a second father to me (I lost my real dad to a heart attack when I was just five years old). When I turned eighteen, I received another important call from Woody: He stunned me with an offer of a part-time job as his assistant. I was walking on air, and in October 1959, I began a career at Topps that lasted for almost forty-one years, until I retired in May 2000.

During that span of time, there were many exciting projects and products I helped develop at Topps—trading cards and stickers from Star Wars to Star Trek, Wacky Packages to Garbage Pail Kids, Michael Jackson to Pokemon, and hundreds more. If anyone ever asks which was my personal

favorite, I always answer, "Mars Attacks." It was an original science-fiction trading card series that Woody and I co-created in 1962, based on a modern-day version of *The War of the Worlds*. At first we called the product Attack from Space, but ultimately we changed it to Mars Attacks, believing the shorter title would appear bolder and more dramatic on our packaging.

Our next decision was to figure out just what these Martian invaders would look like. Somehow, the cliché of little green men from another planet just didn't seem dramatic enough.

My love of old comic books brought to mind an issue of E.C.'s *Weird Science* from 1952, with a striking cover illustration by Wally Wood. The cover depicted UFOs landing on the Earth and releasing a group of large-brained, foreboding aliens onto our world. The invaders were pretty hideous, like nothing I had ever seen before—until in 1955 when I saw a similar-looking creature in the Universal movie *This*

Island Earth. Those big-brained aliens were the perfect inspiration for the Martians in our trading card series.

Woody and I contacted Wally Wood (who back in 1961 had drawn a series of Believe It or Not! spoof cards for us called Crazy Cards). This time we asked him to help us visualize our Martian card concept. Wally, one of the most talented artists who ever put a pen to a sheet of paper, took on the assignment. His initial artwork looked beautiful, yet we felt they were a little subdued; we required more drama and excitement to be sure to catch our young audience's attention. Each Mars Attack card needed to achieve the impact of a paperback cover, with a dramatic story clearly detailed at first glance.

We contacted another comic book veteran, Bob Powell, who had penciled a fairly violent series of trading cards called Civil War News for Topps in 1961. Bob submitted two or three thumbnail sketches for every scenario we gave him, and then Woody and I picked our favorite composition. He would then render a tight five-by-seven-inch pencil drawing on illustration board. That finished art was then forwarded to our painter, Norm Saunders, one of the most lauded pulp cover illustrators of the '40s and '50s. We felt very lucky to have Norm working with us on Mars Attacks. I loved watching him paint over the Powell pencils. He created beautiful, colorful masterpieces, working with a fine paintbrush under a magnifying glass, filling each card with more and more dramatic detail.

It took us six months to complete the artwork for the entire series of fifty-five Mars Attacks trading cards. Before sending the artwork to the printer, it was customary to run the material by the Topps president, Joel Shorin, for review. Usually Joel nodded approvingly and wished us good luck, but not so fast with those Mars Attacks cards! Joel felt that many of the images went too far in depicting violence

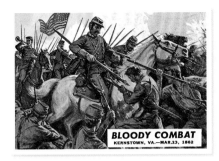

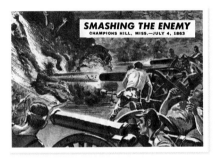

TOP: Civil War News (1962) no. 12, "Bloody Combat." **BOTTOM:** Civil War News no. 48, "Smashing the Enemy," which shares a title with Mars Attacks card no. 50 (pages 110–11).

and brutality. Not the least of his concerns was the presence of too many scantily clad women. Based on Joel's strong words, we sent back at least a dozen paintings to Norm Saunders for modifications. He toned down the more violent images, eliminating some of the bloodshed, and the women revealed far less cleavage and flesh in the modified artwork. Despite these changes, Joel still feared bad publicity, so he decided to remove our regular corporate copyright line from the backs of the trading cards and replace it with the copyright "Bubbles Inc."

It wasn't long after Mars Attacks shipped that newspapers began to run feature stories citing the mayhem depicted on the trading cards,

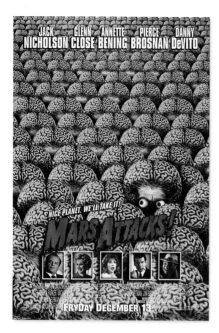

Movie poster for *Mars Attacks!* (Warner Bros., 1996). "The original cards were so beautiful," director Tim Burton told *Cinefantastique* magazine in January 1996. "They were really pure, not campy. They had a lurid quality that I like."

and Topps began to have second thoughts about shipping additional sets into new markets. The final straw occurred when Joel Shorin received a call from a friend in Connecticut who also happened to be the local district attorney. In no uncertain terms, Shorin was told that Mars Attacks was "unsuitable for children," and he was cautioned about releasing more of the trading cards into the state. Sadly, the combination of bad press, some negative letters from concerned parents, and the DA's phone call, brought an end to Topps's plans to expand the series.

While Mars Attacks was never shipped nationally, it made a huge impact on the consumers who had seen the cards. Now, years

later, fans young and old still try to complete their collections, despite the rarity of the cards. Any of these vintage cards appearing for sale are quickly grabbed up and sold. Today, a complete set of the fifty-five original 1962 Topps Mars Attacks cards in mint condition is valued at twenty-five thousand dollars—a pretty good increase for a product that initially sold for a nickel a pack, or a penny a card. More extraordinary, an original wax wrapper sells for over five hundred dollars, and an empty Mars Attacks display box (rarely found) is scooped up for over a thousand dollars!

In 1962, Topps received about thirty letters from students attending the same public school. It was obviously a class assignment, as all the letters had the same basic message, "Mars Attacks trading cards are not suitable for children." Each student writer expressed hope that we would replace the series with something "more educational." One letter, however, contained an additional final sentence: "We really love collecting your Mars Attacks cards. It is our teacher who is making us write this letter to you." A true confession at the very end!

Mars Attacks bubble-gum trading cards are fifty years old and have survived their early criticism. Over the years, there have been action figures, model kits, comic books, life-size masks, hardcover science-fiction novels, and additional trading card sets.

In 1996, Hollywood called, and famed director Tim Burton brought Mars Attacks to the screen with an all-star cast including Jack Nicholson, Glenn Close, Annette Bening, Pierce Brosnan, Danny DeVito, and Sarah Jessica Parker.

More toys, a line of apparel, a new comic book series, and additional trading cards are in the works as the Mars Attacks story continues. What else lies ahead? Tough to predict. I've been surprised so often that all I can do is look up at the stars at night and try to contemplate the possibilities!

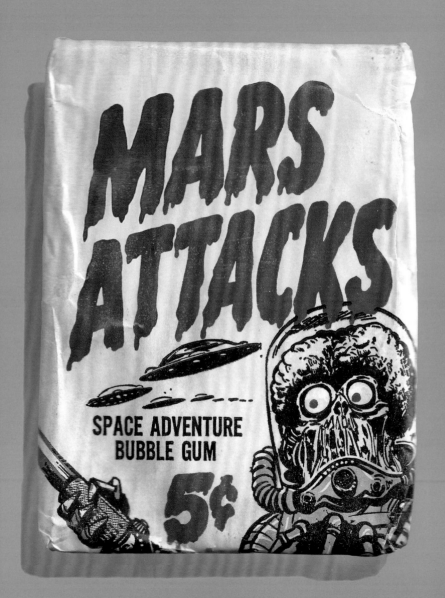

 1

THE INVASION BEGINS

The Martian leaders voted and decided that Mars would have to attack the Earth. Life on the 4th planet would not be able to continue much longer. Martian scientists had reported to their government that atomic pressures had been building up beneath the surface of Mars for many years. A mammoth atomic explosion was weeks away, perhaps only days. The explosion would destroy all life on Mars, turning the planet into a barren wasteland. To protect the survival of their civilization, the Martian officials plotted the conquest of Earth. The fearless Martian warriors were prepared for their journey through space, confident that their weapons would soon conquer earth.

SEE CARD 2
MARTIANS APPROACHING
COLLECT THE SET OF 55 CARDS

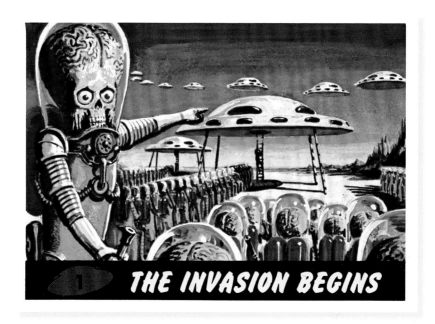

THE INVASION BEGINS

"The idea to start on Mars was Woody's," says co-creator Len Brown, referring to Topps creative director Woody Gelman, who developed the series with him. "We worked fairly sequentially, as I recall, so this was the first card Norm Saunders painted."

MARTIANS APPROACHING

The long journey through space was over and the Martian soldiers were eager to start the attack. Finally at rest after traveling 48,000-000 miles, the saucers awaited the instructions from their home base on Mars. Powerful weapons had been transported across space . . . weapons so destructive that Earth would be crippled beyond repair. Centuries ago the Martians had learned how to harness the sun's energy. This solar energy now operated the deadly weapons that Mars used in its battles. Long ago the solar power was used to build beautiful cities and ingenious inventions. All this was changed now . . . Earth was to be conquered.

SEE CARD 3
ATTACKING AN ARMY CAMP
COLLECT THE SET OF 55 CARDS

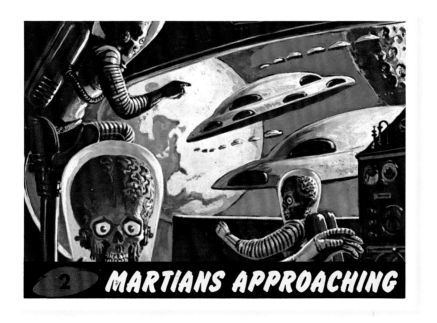

2 **MARTIANS APPROACHING**

Artist Norm Saunders produced most of the art for Mars Attacks from his uptown Manhattan apartment and visited Topps's Brooklyn offices to deliver the finished paintings, feeling that was safer than sending them by mail. Saunders also brought his paints with him to Topps, in case he had to do any retouching.

 ATTACKING AN ARMY BASE

A quiet Sunday afternoon was turned into a tragedy as flying sau-
cers launched their first attack against Earth. Circling an Army
training base, the Martians observed the camp from high in the
sky. Swooping down from behind the clouds, the invaders set fire to
the military barracks. Soldiers ran outside trying to discover why
their quarters had burst into flames. The young men were cut down
by the strange rays which were unknown to our civilization. Officers
and privates lay dying on the ground as the saucers continued their
onslaught against the Army base. Word
of the disaster shocked the world, and
forced the president to declare "a state
of national emergency."

©BUBBLES INC. PRTD. IN U.S.A.

SEE CARD 4
SAUCERS BLAST OUR JETS
COLLECT THE SET OF 55 CARDS

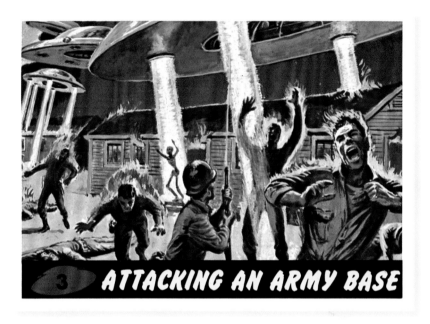

"The first artist we tried out was Wally Wood, because he had done an alien on the cover of an issue of *Weird Science*. We called Wally in and told him we wanted a creature with a big brain, and he did a lot of early sketches for us." (See "Behind the Scenes and More," starting on page 182.)

 SAUCERS BLAST OUR JETS

Under orders from the White House, a squadron of jet planes was sent up to try and locate the enemy saucers which had attacked a U. S. military base. For the first hour there wasn't any sign of a spaceship. Just as the pilots headed back to their base, radar revealed four saucers soaring toward the jets at fantastic speeds. The U. S. planes fired at them, but the ammunition bounced harmlessly off the metallic exteriors of the saucers. Returning the fire, the alien ships sent two jets crashing to the Earth in flames. One of the pilots tried to get a look at the inside of a spaceship. Seeing this, the saucer smashed itself in the jet without any damage to itself.

©BUBBLES INC. PRTD. IN U.S.A.

SEE CARD 5
WASHINGTON IN FLAMES
COLLECT THE SET OF 55 CARDS

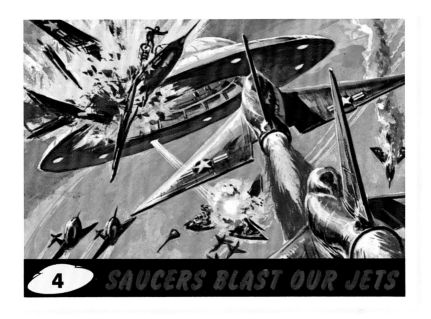

After Wally Wood pinned down the look of the Martians, comics veteran Bob Powell was brought in. "We felt that Bob's layouts had a better sense of drama than anyone else's. When it was clear that Bob was going to be our penciler, we asked him to give us two or three versions of each scene that we described. I wish we still had more of those roughs."

 # WASHINGTON IN FLAMES

The United States waited anxiously for word from Washington concerning the safety of the president. With the nation's capital under seige, it had been difficult to receive accurate reports on the damage that had been done there. Frightening rumors had reached some of the cities that the White House was in flames, after being battered by the Martian saucers. Such famous landmarks as the Lincoln Memorial and the Washington Monument had been completely destroyed. Fleeing citizens reported the entire city in flames. The Martians did not spare anyone from their vicious death rays and fear for the president's welfare continued to grow by the hour.

SEE CARD 6
BURNING NAVY SHIPS
COLLECT THE SET OF 55 CARDS

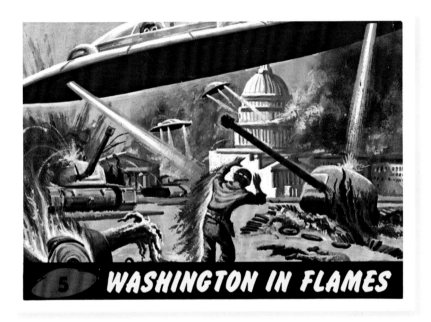

5 WASHINGTON IN FLAMES

After getting back several rough sketches for each card concept, Gelman and Brown would pick their favorite. Powell would then tightly pencil the scene on a sturdy five-by-seven-inch illustration board, which the artists would paint directly over. This process, in effect, eliminated an important layer of the original artwork forever.

 6

BURNING NAVY SHIPS

A fleet of Naval destroyers was on a routine mission off the Philippine Islands when disaster struck. A group of saucers suddenly appeared, circling the ships at fantastic speeds. Flying dangerously low, the objects opened fire. Powerful rays rocked one of the ships and turned it into a flaming coffin. The sailors aboard the other ships raced to their weapons to try to repel the attack. But there wasn't any means of fighting the saucers, for they easily dodged the gunfire. Even when a saucer was hit, the ammunition had no effect on the Martian ships. Seeing the futility of it, the admiral issued orders for the fleet to retreat before all the boats were destroyed.

SEE CARD 7
DESTROYING THE BRIDGE
COLLECT THE SET OF 55 CARDS

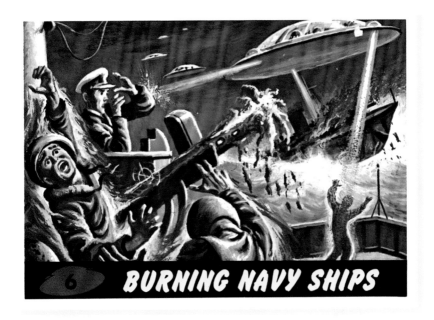

BURNING NAVY SHIPS

While often cited for illustrating the entire series, Norm Saunders had some help. Though he did paint most of the Mars Attacks cards, other artists were brought in to keep the project on schedule when Topps requested the release be moved up. Additional painters included well-known pulp artists Geoffrey Biggs and Maurice Blumenfeld.

 # DESTROYING THE BRIDGE

The Martian invaders struck out at the West Coast of the United States as flying saucers released their potent rays over The Golden Gate Bridge, while thousands were traveling home after a day at the office. At the height of the rush-hour the Martians attacked the mammoth structure, melting the huge beams that supported the bridge. Cars plunged into the icy waters bringing death to the helpless passengers within. Screaming hysterically, the people had no way of escaping their steel coffins. A Coast Guard vessel was cruising under the bridge when it was struck by the falling debris. Several crew members surviving the disaster told of the scenes of horror they had witnessed.

©BUBBLES INC. PRTD. IN U.S.A.

SEE CARD 8
TERROR IN TIMES SQUARE
COLLECT THE SET OF 55 CARDS

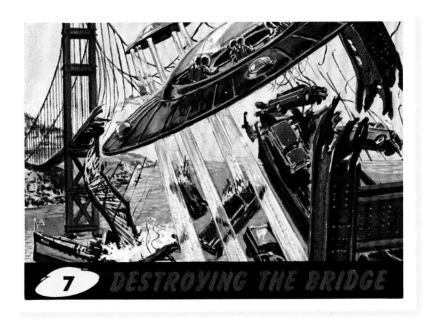

7 DESTROYING THE BRIDGE

Of the Golden Gate Bridge, Brown notes, "We tried to pick the most iconic landmarks that kids would recognize." He and Gelman felt that showing familiar locations would give the series greater impact and make the destruction feel more real.

 TERROR IN TIMES SQUARE

Death and destruction came to the streets of New York as the flying saucers attacked the busiest city in the world. Despite warnings of the impending raids by newspapers and radios, citizens conducted their business as usual on the city streets. Martian spaceships appeared without any warning, blasting and burning the New York skyline with their penetrating power. People panicked at the sight of alien spaceships, fleeing for shelter in buildings and subways. The death ray struck time and again, igniting Broadway with flash fires. People were trampled as they tried to escape the invaders' weapons. What once was known as the Great White Way had become a showcase of horror.

SEE CARD 9
THE HUMAN TORCH
COLLECT THE SET OF 55 CARDS

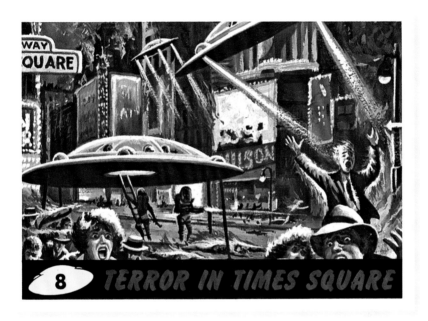

Brown, Gelman, Powell, and Saunders all worked together on the earlier Civil War News card set that influenced the look and feel of Mars Attacks. Civil War's bloody tone was itself inspired by the Horrors of War card set released by Gum, Inc., in 1938.

 9

THE HUMAN TORCH

The Army rushed armed units into the city in an attempt to protect the citizens from the Martian invaders. Tanks and bazookas were a common sight in the streets, as people hid in their basements and shelters. Saucers constantly flew over the city, destroying buildings and lives with its deadly beams. Attacking the soldiers, the Martians fired their death-rays at them. The helpless military force was turned into flames as the aliens continued their reign of terror. No known weapons seemed to be able to combat the saucers. Terrorizing the cities of the United States, the Martians had the people of America trembling with fear.

©BUBBLES INC. PRTD. IN U.S.A.

SEE CARD 10
THE SKYSCRAPER TUMBLES
COLLECT THE SET OF 55 CARDS

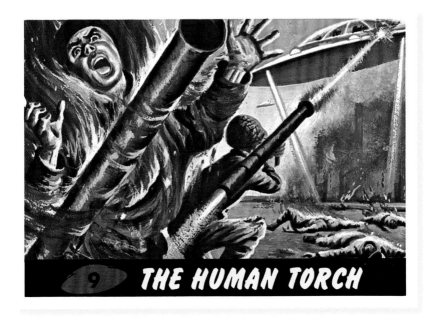

THE HUMAN TORCH

Gelman, a former animator, comic book writer, and co-creator of Topps's own Bazooka Joe comics, was an accomplished cartoonist and often developed the card concepts with Brown. Gelman storyboarded many scenes himself before handing them to series penciler Bob Powell for embellishment.

10 THE SKYSCRAPER TUMBLES

The Empire State Building crackled in flames as hundreds of workers were trapped inside the famous skyscraper. The attack took place at the end of a working day, just before men and women were to leave their offices to return to their families. Thousands of lives were lost as people fled for their cars, hoping to escape the flaming city. Autos piled onto the roads, with police completely helpless during the panic. Fires sprang up everywhere, as the saucers continued their assault on the city. The fire department was helpless because of the jammed roads. New York City was burning down and no one could do anything to help.

©BUBBLES INC. PRTD. IN U.S.A.

SEE CARD 11
"DESTROY THE CITY"
COLLECT THE SET OF 55 CARDS

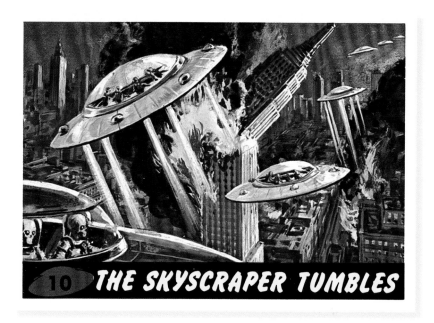

10 ▶ THE SKYSCRAPER TUMBLES

"Woody Gelman's theory was that every card should look like either a pulp cover or a movie poster or a paperback jacket—the viewer should have an 'Oh my gosh!' reaction when they see it. He really wanted each card to tell a story."

 "DESTROY THE CITY"

The flying saucers descended, landing on the outskirts of the city. Carrying powerful atomic weapons, the invaders stalked through the streets. Citizens trying to hide were wiped out with one blast from the alien heat guns. The Martians set about destroying the city... burning the homes, the schools and the factories. All vehicles were demolished and communication was completely disrupted. Those that survived lived in a nightmare world, afraid to wander outdoors and yet facing starvation if they remained locked in their basements. Once all the property had been destroyed, the Martians continued patrolling the city, gunning down any stray survivors without mercy.

©BUBBLES INC. PRTD. IN U.S.A.

**SEE CARD 12
DEATH IN THE COCKPIT**
COLLECT THE SET OF 55 CARDS

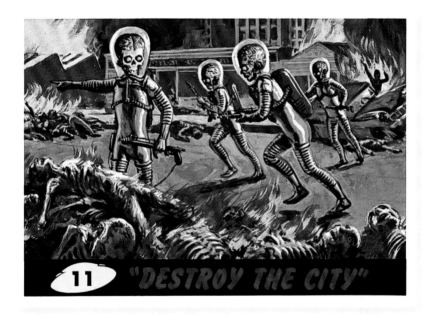

The horizontal structure of the art in Mars Attacks and other early Topps series was an attempt to capture the feel of CinemaScope wide-screen movies. Years later, Topps would release a series of "Widevision" Mars Attacks trading cards based on the 1996 feature film.

 DEATH IN THE COCKPIT

The U. S. Army sent up jet fighters in an attempt to intercept the flying saucers. The saucers darted back and forth, easily dodging the planes. One jet pilot, more persistent than any of the others, tried to follow the alien ships. Although he knew he couldn't catch up with the saucers, the pilot hoped to learn where they were stationed. The Martians soon became aware of the jet following them and sent a saucer back to blast him out of the sky. The alien ship soared head-on toward the jet and fired its potent ray. The cockpit was instantly transformed into a flaming coffin, giving the pilot no chance to parachute to safety.

SEE CARD 13
WATCHING FROM MARS
COLLECT THE SET OF 55 CARDS

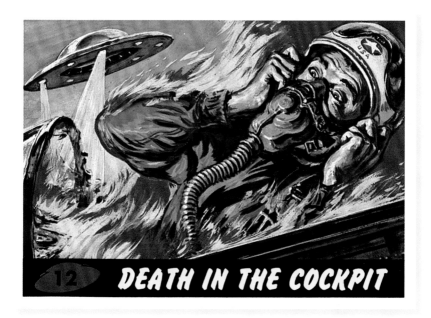

DEATH IN THE COCKPIT

12

A similar scene to this is shown in one of Wally Wood's development sketches (page 185). Brown says, "Topps unfortunately felt that showing skeletons was too gruesome for kids, but I always thought the look of terror on the man's face here was much more horrifying."

 WATCHING FROM MARS

From their observation post in the capitol city of Mars, the Martian leaders excitedly watched the progress of the invasion against Earth. Their advanced civilization had developed TV cameras which were capable of sending pictures millions of miles through space. Through their long range tele-viewers they watched the Earth's cities being destroyed. Paris was crushed under the potent heat rays from the saucers . . . London was immobilized as the Martians stalked the streets, seeking new victims . . . Rome's historical structures were demolished by the invaders. The Martian leaders were pleased with what they saw and toasted the future success of the invasion.

©BUBBLES INC. PRTD. IN U.S.A.

SEE CARD 14
CHARRED BY MARTIANS
COLLECT THE SET OF 55 CARDS

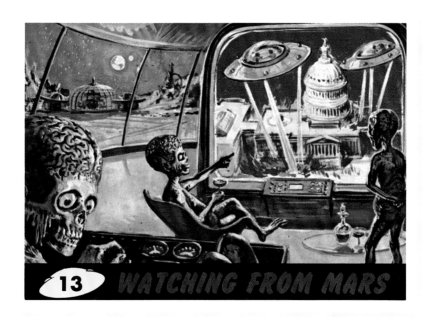

13 — WATCHING FROM MARS

"Woody came up with this scene. He said, 'Let's have them drinking martinis like they're toasting their victory.' I remember saying to Woody, 'Should it look like an Earth martini glass or should it be something a little weirder?' We ended up going with a regular martini glass so it would be more recognizable."

14 *CHARRED BY MARTIANS*

The young doctor was driving home after visiting a patient when he heard a humming noise overhead. Looking up, the medic was terrified at the sight of a flying saucer tailing him. Curiously the Martians seemed to be studying him and his car. As the doctor pressed his foot down harder on the gas pedal, the speedometer pushed past the 70-mile-per-hour mark. The saucer kept a steady pace overhead. Trying to outrace the Martians was useless but the doctor further accelerated his speed to over 100 m.p.h. Powerful atomic beams flashed out of the saucer and glowed on the car. The rear of the auto burst into flames, and the car overturned into a ditch.

©BUBBLES INC. PRTD. IN U.S.A.

SEE CARD 15
SAUCERS INVADE CHINA
COLLECT THE SET OF 55 CARDS

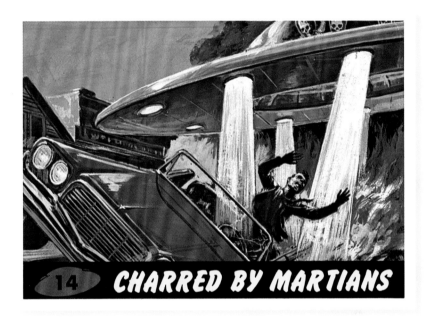

14 **CHARRED BY MARTIANS**

The original test run was called Attack from Space (only a handful of these sets was produced), but the title changed when the set was released officially. Recalls Brown, "We thought the fewer words of Mars Attacks would look bolder on the wrapper, like more of a headline."

SAUCERS INVADE CHINA

No country on Earth was safe from the Martians' devastating attack. The saucers always struck swiftly and without warning, crippling the manpower of the world. The four corners of the Earth were drenched in blood as the aliens tried to crush all of the Earth's resistance to the invasion. In China, the people were terrorized by frightful weapons that not even their folklore foretold. Farmers who were nearly frightened to death by airplanes, found the flying saucers to be twice as awesome. Believing the attacking saucers were the will of angry gods, the Chinese peasants made little effort to escape the slaughter.

©BUBBLES INC. PRTD. IN U.S.A.

SEE CARD 16
PANIC IN PARLIAMENT
COLLECT THE SET OF 55 CARDS

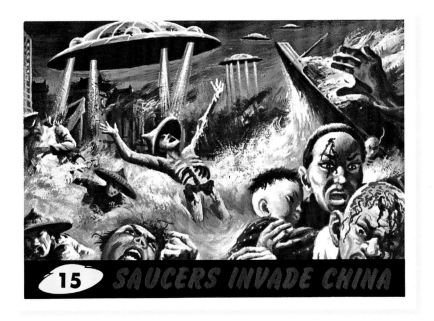

15 SAUCERS INVADE CHINA

"We were planning the next card set to follow Civil War News, and science fiction was the obvious choice. We thought about a time travel series, but we didn't know if we could come up with enough scenarios." Inspired by H. G. Wells's *The War of the Worlds*, Brown and Gelman eventually settled on a more basic concept: an alien invasion.

 ## PANIC IN PARLIAMENT

An emergency meeting of Parliament came to an abrupt end when Martian saucers attacked the famous hall. Ironically, the topic being discussed at the time was about military plans to beat back the space invaders. Burning a hole through the ceiling, England's top government officials watched the aliens drop into the assembly hall. Falling debris injured many of the statesmen before they could flee for safety. The Martians set fire to the building and the flames soon crackled out of control. Several of the officials were burnt alive as they scrambled unsuccessfully for the exit doors. The usually reserved meeting hall was filled with screams of frightened men as the Martians entered.

SEE CARD 17
BEAST AND THE BEAUTY
COLLECT THE SET OF 55 CARDS

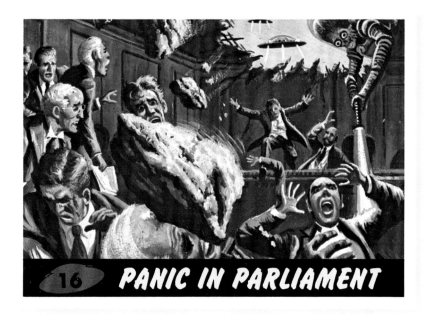

16 PANIC IN PARLIAMENT

Brown recalls that the set's release in the United Kingdom caused controversy. "They were incensed. We heard from our English subsidiary that a speaker in Parliament brought up this card, about how awful it was, from a British point of view, that we were selling cards like this to children in our country."

 BEAST AND THE BEAUTY

Nothing seemed to be able to stop the menacing invaders as they conducted their vigil of terror throughout the world. No barrier was strong enough to withstand the Martians' powerful weapons, which were slicing through concrete as if it were a slab of butter. Defenseless victims were whisked away during the night, leaving families without any idea of their loved ones' fate. The aliens destroyed houses of worship, leaving the terrified population without any sanctuary to turn to. Fear and panic gripped the world, and civilization became paralyzed by the Martians' reign of horror.

SEE CARD 18
A SOLDIER FIGHTS BACK
COLLECT THE SET OF 55 CARDS

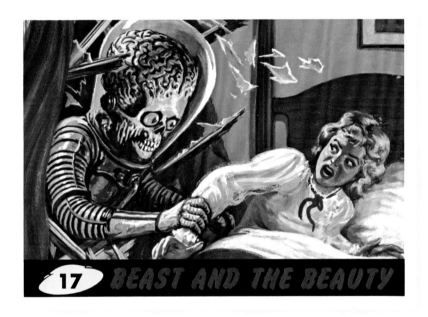

17 BEAST AND THE BEAUTY

The "Beauty" in this card was originally painted by Saunders wearing a small, revealing nightie. Feeling the art was too sexual for the kids they'd be selling to, management at Topps insisted the women be covered. "Norm painted great flesh. There was a lot of skin and cleavage showing. I was sorry we had to change this one."

 A SOLDIER FIGHTS BACK

Army and Marine units were stationed in the countryside to try to protect frightened citizens that had evacuated the city. Families lived in caves, depending on nature for their food. The Martians, discovering this, sent warriors out to hunt them down. Watching the small backroads, the invaders destroyed all the humans they saw. A U. S soldier was patrolling his sector when he saw several Martians wrecking automobiles. Unable to control his anger he darted out of his hiding place, determined to kill the hated enemy. Before the heroic soldier could strike, a ray from a Martian's gun ended his life.

©BUBBLES INC. PRTD. IN U.S.A.

SEE CARD 19
BURNING FLESH
COLLECT THE SET OF 55 CARDS

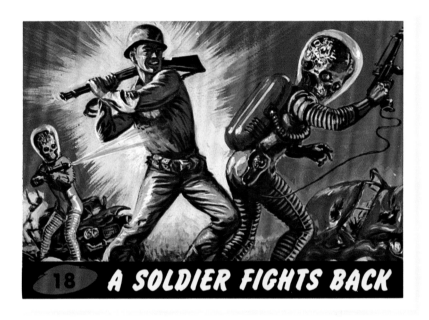

18 A SOLDIER FIGHTS BACK

"We didn't really discuss whether the Martians were any certain height," says Brown. Despite being portrayed in the Tim Burton film as small, impish aliens, the Martians were never thought of that way during development of the card series. "I think the idea was they were human sized."

BURNING FLESH

The Martian invaders used atomic ray guns as they patrolled the streets of the city. Any unfortunate Earthman in the path of the aliens was easily destroyed. Human flesh and clothing was not able to withstand the heat of radiation from the ray guns. A group of young men banded together in a plot to cut the oxygen lines on the Martians' spacesuits. Creeping up slowly behind them, the youths were poised to strike. Suddenly the spacemen whirled around, as if an inner sense had warned them of their peril. Firing their guns, the invaders quickly wiped out their attackers. The Martians continued on their way, leaving only the charred bones of the brave youths behind them.

©BUBBLES INC. PRTD. IN U.S.A.

SEE CARD 20
CRUSHED TO DEATH
COLLECT THE SET OF 55 CARDS

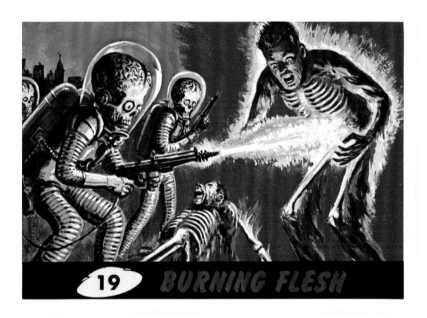

19 BURNING FLESH

"We were optimistic when we tested the series as Attack from Space, but I don't think we shipped all that many sets with that title. We would typically do a test run of maybe four or five cases and get it into a dozen or so local stores and monitor the sales."

 20 ## CRUSHED TO DEATH

The terror caused by the flying saucers was endless. It seemed as if the Martians always had a new form of horror to inflict upon the people of Earth. Often the invaders would clear the streets of wreckages by ejecting a giant shovel from their spaceships. The giant shovels would sweep the streets clear by depositing the unwanted material in the river or in a vacant lot. Once the Martians amused themselves by trapping a number of men and women in the powerful steel shovels. The people were pushed through the city streets, receiving bruises and gashes despite their cries of pain. The unfortunates were finally crushed against the walls of brick buildings.

©BUBBLES INC. PRTD. IN U.S.A.

SEE CARD 21
PRIZE CAPTIVE
COLLECT THE SET OF 55 CARDS

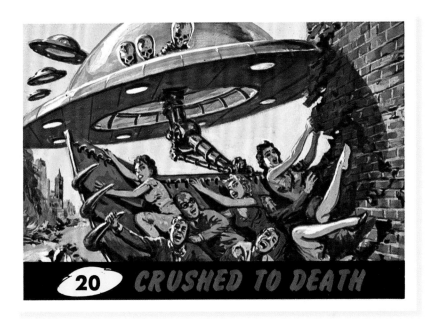

20 CRUSHED TO DEATH

In-house Topps staff, including Jane Fitzsimmons, were responsible for packaging and other illustrations, including the original wrapper and display box. Foreign editions used different wraps produced independently from Topps in the United States.

 PRIZE CAPTIVE

The hideous Martians walked through the cities, exploring the deserted buildings with curiosity. Often the aliens would rummage through vacant apartments, fascinated by the belongings of the Earthmen. The Martians seemed very intrigued by the dresses and suits left in the closets of the frightened inhabitants. In one closet, an Earth girl that had not fled the city cowered in fear behind one of her dresses as a Martian looked over her belongings. Spying the hidden woman, the creature snatched her in his arms. The girl kicked and screamed at the touch of the alien. The Martian was so startled by the woman's antics, that he released her. Taking the opportunity, the girl fled.

SEE CARD 22
BURNING CATTLE
COLLECT THE SET OF 55 CARDS

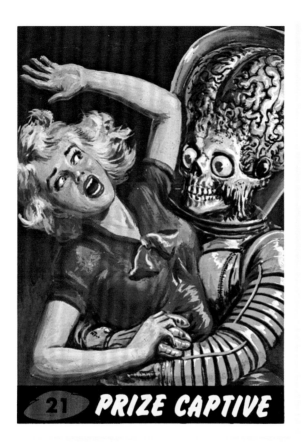

"We could show skeletons of dead human beings or people in flames, but we couldn't show the rounded, pretty flesh of a woman's shoulder—we had to paint over the original artwork after Topps objected. In this card, we had to cover the woman right up to her neck!"

 22 ## BURNING CATTLE

By attacking the food supply of the world, the Martians hoped that they would be able to bring the Earth to its knees. The leaders of the invasion ordered the saucers to destroy all of the animals and farm land that existed. Sweeping over the nations of the world, the saucers destroyed acre after acre of wheat land. Animals were burnt to death by the searing heat rays that the Martians fired. Farmers stood by watching helplessly as cows, horses and chickens were destroyed. Trying to save as much of the livestock as possible, farmers hid the animals in shelters and barns. Some of the animals were kept in the family's own living quarters to keep them safe from the attacks.

©BUBBLES INC. PRTD. IN U.S.A.

SEE CARD 23
THE FROST RAY
COLLECT THE SET OF 55 CARDS

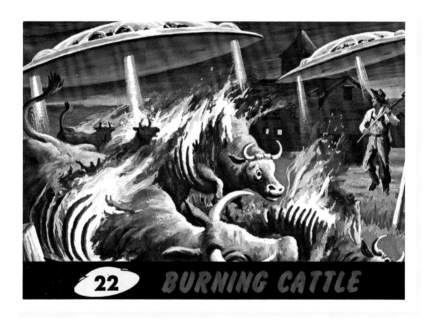

22 BURNING CATTLE

"It was pure inhumanity," Brown recollects. "The saucers are striking the Earth, and here they are burning the cattle up and just destroying whatever they can." This scene was directly translated to the screen by Tim Burton in his 1996 film.

 THE FROST RAY

Martian saucers constantly flew over the large cities scouting for signs of life. People rarely walked through the streets during the daytime, unless it was a matter of great importance. A group of emergency volunteers were on their way to a city hospital when a saucer spied them. Seemingly taunting the frightened people, the ship flew close to them as they walked swiftly through the back streets and side alleys. The hospital was just two blocks away and the group tried to run to it for shelter. It was then that the invaders revealed a new chilling horror. A ray released from the flying saucer froze the volunteers into icemen. The rays of the sun had no thawing effect at all.

SEE CARD 24
THE SHRINKING RAY

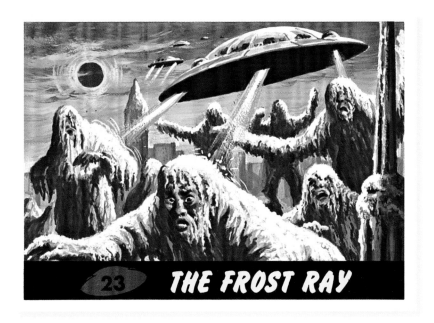

THE FROST RAY 23

"What other ways could they torture humans? What else could they do? First they burn them, so now let's freeze them." Conceptualizing the various Martian weapons and powers was a process Brown enjoyed. "Imagine spending time talking about these things!"

 THE SHRINKING RAY

Two soldiers crouched behind some debris, watching the flying saucer land. Stepping out from behind a sliding panel of the saucer was a sinister alien. The Martian moved in the direction of his observers, although he wasn't aware of their presence. One of the soldiers became so incensed at the sight of the enemy, that he charged the Martian without thinking of its consequences. His companion tried to hold him back, but it was too late. Alerted to the danger, the Martian pulled out a gun. A ray hit the enraged Earthman and instantly the soldier started to shrink. His buddy watched horrified as the six-foot-tall man was reduced to inches, before vanishing from sight.

©BUBBLES INC. PRTD. IN U.S.A.

SEE CARD 25
CAPTURING A MARTIAN
COLLECT THE SET OF 55 CARDS

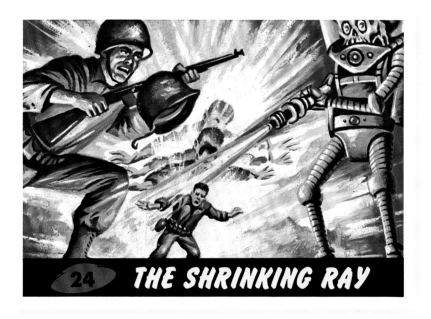

24 THE SHRINKING RAY

Many of the concepts in Mars Attacks were taken from popular science-fiction, horror, and pulp trends of the day. "*The Incredible Shrinking Man* [1957] was a movie I loved. This scene contains one of the many elements Woody and I would talk about."

25 CAPTURING A MARTIAN

The Martians never let any soldiers get close to them, blasting any approaching Earthmen with their death rays. However one of the aliens was so interested in watching a burning building that he never noticed a group of soldiers sneaking up behind him, until it was too late. Carrying a huge fishing net, a couple of the Earth fighters wrapped it over the surprised victim. The spaceman lashed out at the soldiers, trying to grab one through the net. A quick jab with a bayonet quieted the alien and he was carried off to Earth's military headquarters. There, trained specialists would attempt to break the language barrier and communicate with the captured Martian.

©BUBBLES INC. PRTD. IN U.S.A.

SEE CARD 26
THE TIDAL WAVES
COLLECT THE SET OF 55 CARDS

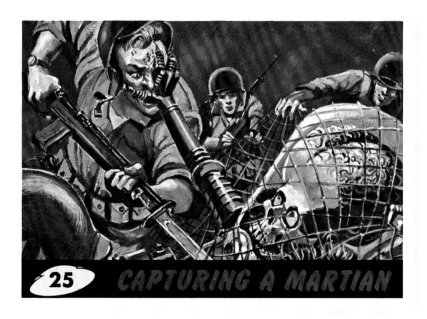

25 CAPTURING A MARTIAN

"I remember being unhappy when we put these captions on the front of the cards. When we were planning the series, and as the paintings were coming in, we didn't realize that's what we were going to do: take about a quarter of an inch of finished art and cover it. I always felt bad about that."

THE TIDAL WAVE

The flying saucers' powers seemed unlimited. Able to destroy any building or human with a blast from its death rays, the Martian ships now turned their terror to the sea. Rays flashed over the oceans of world and calm waters suddenly became turbulent. Waves crashed against the shores, building in momentum and size under the strange Martian power. Finally reaching mammoth proportions, immense tidal waves crashed furiously into shore cities. Sea vessels were tossed through the city streets by the powerful waves. Huge buildings toppled under the pressure of the erupting waters, and the streets vanished under the twisting sea.

©BUBBLES INC. PRTD. IN U.S.A.

SEE CARD 27
THE GIANT FLIES
COLLECT THE SET OF 55 CARDS

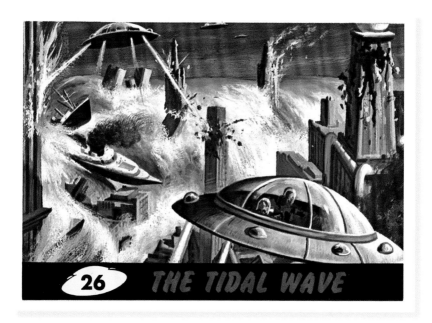

26 THE TIDAL WAVE

Bob Powell, in addition to producing roughs for most of Topps's nonsports cards in the 1960s—including Civil War News and Batman—also contributed drawings of ball players that were printed on the backs of their annual baseball card sets.

THE GIANT FLIES

As if the Martian death rays hadn't caused enough destruction and tumult to the people of Earth, a new horror was suddenly released on them. Saucers flew over heavily populated cities, releasing huge insects to destroy property and lives. The Martians had gathered insect specimens from Earth, enlarging them with their scientific equipment to 500 times their regular size. The normally annoying pests were now transformed into deadly menaces, attacking any slow-footed human around. The new peril made Earth citizens more helpless than before, for at any time one of the winged terrors might swoop out of the sky to claim another victim.

©BUBBLES INC. PRTD. IN U.S.A.

SEE CARD 28
HELPLESS VICTIM
COLLECT THE SET OF 55 CARDS

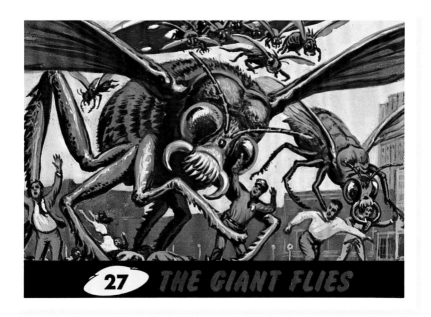

27 THE GIANT FLIES

"Giant insects were one of the weapons that the Martians used against Earth. We wanted visual elements that were popular in science-fiction movies." Films like *Them* (1954) and *Tarantula* (1955) inspired the use of enormous bugs.

HELPLESS VICTIM

28

Without any warning except for the thunderous flapping of their huge wings, the giant insects would sail down out of the sky. Always hunting new prey, the creatures terrified the people even more than the Martians had. Huge colonies of giant insects sprang up on the outskirts of the city and the bugs would conduct nightly raids looking for food and human victims. Often the creatures would carry back humans to their camp, where the poor souls would be helpless. The powerful insects were strong enough to carry 200 pound men through the air. Nobody was safe, when the bugs were flying in search of food.

SEE CARD 29
DEATH IN THE SHELTER
COLLECT THE SET OF 55 CARDS

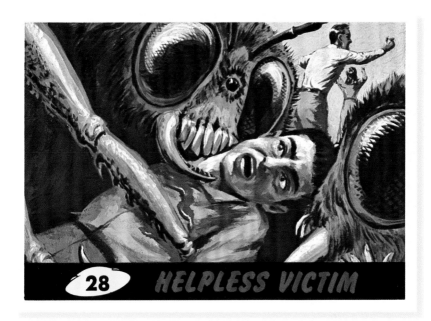

28 HELPLESS VICTIM

"I credit Bob Powell for these insects," Brown states. "Norm had the freedom to change things if he thought they didn't look right—because Norm was so good—but Bob Powell did pretty tight pencils."

 ## DEATH IN THE SHELTER

The emergency shelters that were set up by the government were supplied with enough food to last 100 people at least a month. Well disguised, the shelters were rarely discovered by the Martians as they flew over them in their saucers. However, when the bugs were released, the danger of discovery was greatly increased. The flying creatures would sense the presence of food and with their appetite increased as greatly as their size, the insects would crash into the shelters. The defenseless people were left at the mercy of the hungry bugs, when the beasts managed to enter a shelter.

SEE CARD 30
TRAPPED!!
COLLECT THE SET OF 55 CARDS

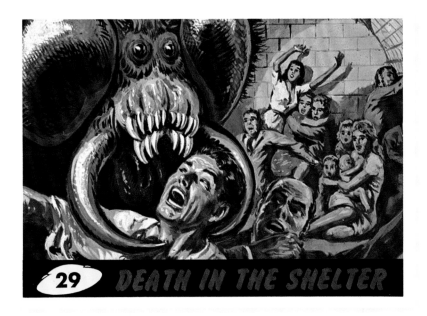

29 DEATH IN THE SHELTER

After publication, many of the original paintings were altered by the artists. These images were reportedly changed at the request of Topps, who briefly considered re-releasing the series with less offensive imagery (see pages 209–21 for Rosem Enterprises' Mars Attacks—The Unpublished Version).

TRAPPED!!

The huge spiders were perhaps the ugliest and most frightening of all the giant insects. The spiders would often spin a web from one side of the street to the other. Automobiles would become hopelessly entangled in the mesh and their owners would have to abandon them. In the country, a spider would often spin a web from one tree to another, manufacturing a net inescapable to any victim trapped within it. On a dark night people didn't see the web and they'd stumble into it blindly. If no one arrived to cut the person out of the web, the victim might die of starvation. If the spider were to return, the helpless victim would be at the mercy of the spider's whims.

©BUBBLES INC. PRTD. IN U.S.A.

SEE CARD 31
THE MONSTER REACHES IN
COLLECT THE SET OF 55 CARDS

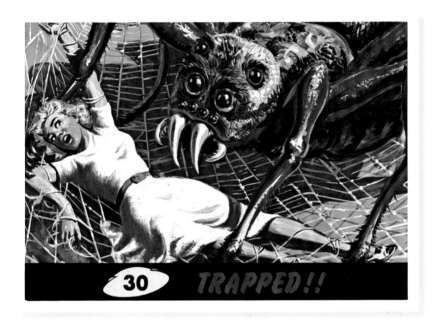

30 TRAPPED!!

"I know I came up with this one," Brown says. "This was almost a cliché in horror magazines, but it must have made a big impact on me in my younger days, because I really wanted to get that image in the series once we were doing insects as part of the invasion." Wally Wood storyboarded an early version of this concept, shown on page 200 (bottom).

 THE MONSTER REACHES IN

Although the entire city had fled to the countryside to hide, a soldier remained to help a lady scientist gather valuable information about the Martians. The couple were so intent on their work that they failed to notice a long tentacle reach into the room, until it had grabbed the woman. Crying out hysterically, the woman was pulled toward the window by the giant creature. The soldier charged the bug with his bayonet and jabbed through the thick skin, again and again. Badly hurt, the insect released the woman and she slumped unconsciously to the floor. Even after their hair-raising escapade, the brave duo remained to finish their work.

SEE CARD 32
ROBOT TERROR
COLLECT THE SET OF 55 CARDS

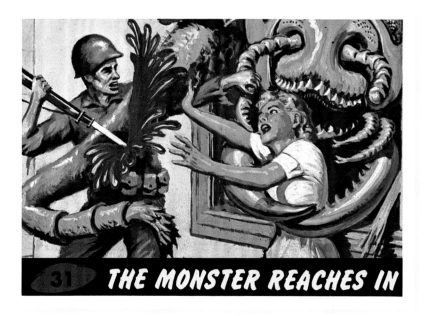

THE MONSTER REACHES IN

Len Brown and Wally Wood would team up again in the mid-1960s to create the super-hero comic book *T.H.U.N.D.E.R. Agents*. Wood named lead character Dynamo's alter ego Leonard Brown, after his friend and co-writer. The characters have been revived several times over the years, most recently by DC Comics in 2010.

32 *ROBOT TERROR*

The sound of metal vibrating through the city streets became an announcement of impending disaster during the Martian invasion. Giant robots stalked the streets, destroying everything in its path. Moving slowly, with a Martian working the controls, the steel monster reached down and plucked terrified people off the side-walks. Its huge pincers held any captive in a death-like grip until the Martian decided to apply the final squeeze. Powerful melting beams seared the buildings and left only rubble in their place. The robot, capable of crashing through brick walls, was made of an alloy unknown on Earth. Military weapons had no effect on the metal monsters.

©BUBBLES INC. PRTD. IN U.S.A.

SEE CARD 33
REMOVING THE VICTIMS
COLLECT THE SET OF 55 CARDS

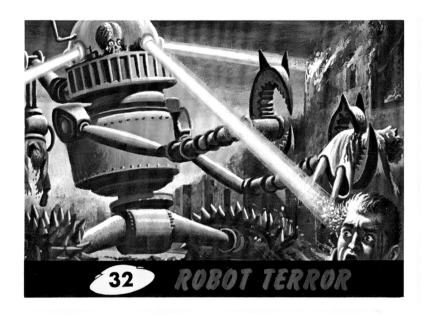

32 ROBOT TERROR

Recalling the inspiration for the Martians' mechanical monstrosities, Brown says, "I go back to the movie serial *The Phantom Empire* [1935], with Gene Autry, and another called *Undersea Kingdom* [1936]. They both used very similar, very clunky 1930s-style robots."

 ## REMOVING THE VICTIMS

The Martians landed and inspected the damage that they had done. Streets were beyond recognition and mighty cities had been all but leveled. Bodies lay on the streets, unfortunate victims of the Martian destruction. By some means the aliens had found a way to communicate with the giant insects that they had created. The bugs followed any instructions given to them from the spacemen. The Martians ordered the creatures to remove the bodies from the streets. Flying insects flew off with several bodies in their claws at a time. The aliens wanted all the streets clear before the people of Mars were brought to Earth to establish a new Martian domain.

SEE CARD 34
TERROR IN THE RAILROAD
COLLECT THE SET OF 55 CARDS

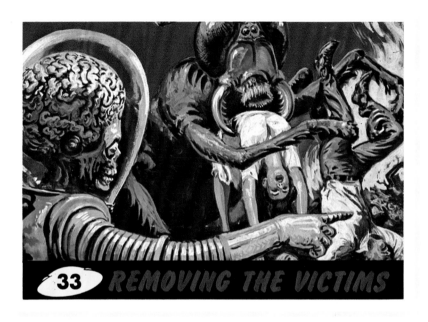

33 REMOVING THE VICTIMS

Controversy erupted when upset parents, teachers, and lawmakers voiced disapproval over the violent and salacious imagery used on the cards. "At the time," Brown says, "we actually kept a file of all the complaints we received."

 ## *TERROR IN THE RAILROAD*

The engineer was ready to pull out of the train station when he looked out at the dark tunnel ahead. At first he couldn't believe his eyes, but after blinking and rubbing them, he was sure. A giant insect was extending a huge claw towards the train. The bug touched the first car, tightening a grip around it. Amused by the little people running around inside, the bug lifted the car and shook it. Screaming men and women risked death on the third rail as they leaped out onto the tracks for safety. The entire station was thrown into a panic as they watched the fascinated insect crush several cars the way a child might crush a toy he had grown tired of.

©BUBBLES INC. PRTD. IN U.S.A.

SEE CARD 35
THE FLAME THROWERS

COLLECT THE SET OF 55 CARDS

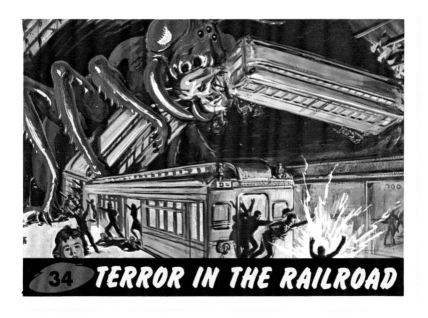

34 TERROR IN THE RAILROAD

Brown and Gelman were surprised by the uproar over the series content. "Our Civil War set was just as gory as Mars Attacks. I suspect because it was historical, people just felt that kids were learning, so the violence was okay."

 ## THE FLAME THROWERS

Soldiers were given powerful flame throwers with which they were to fight off the giant insects. A patrol of soldiers were marching along the countryside when they came upon a colony of the bugs. The creatures noticed the intruders immediately and moved menacingly toward them. The commanding officer gave the order to use the flame throwers and the men quickly responded. Searing streams of fire burst forth and lashed out at the on-coming insects. The creatures shrieked in pain as the flames struck on target. The hot fire consumed the bugs, but their deafening inhuman screams continued to ring through the valley. At last the soldiers could cope with the monsters.

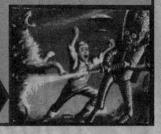

SEE CARD 36
DESTROYING A DOG
COLLECT THE SET OF 55 CARDS

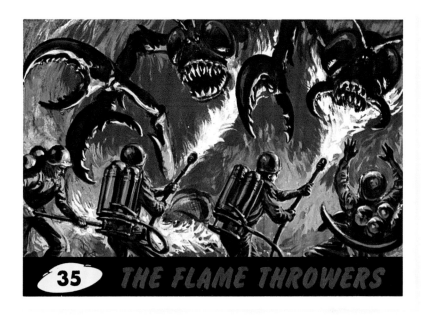

35 THE FLAME THROWERS

Following the initial release of Mars Attacks in 1962, the card set brought more backlash and controversy than sales, so Topps chose not to distribute the series nationally. Despite its fame today, the original set was never widely available, and very few were produced.

36

DESTROYING A DOG

The Martians not only attacked the big cities, but also struck at the less populated sections of the country. Frightened citizens had to flee into the woods for safety or be burned with their homes. The invaders would leave their saucers and search small caves, looking for signs of the hiding families. In one cave, a Martian found a group of six people huddled together in fear. Before the invader could use his death weapon, a dog leaped up at the alien. The startled spaceman ran out of the cave, followed by the animal and its young owner. The invader then turned his deadly ray on the barking dog, destroying it as the young boy cried out in horror.

©BUBBLES INC. PRTD. IN U.S.A.

SEE CARD 37
CREEPING MENACE
COLLECT THE SET OF 55 CARDS

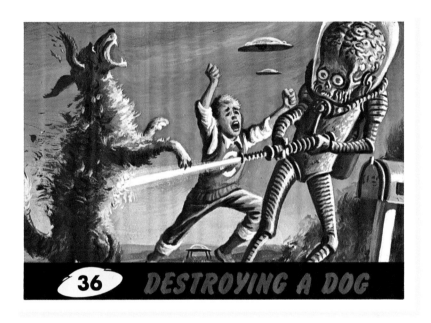

36 DESTROYING A DOG

Perhaps controversy did not come as a complete surprise to Topps management, who weren't thrilled with their first look at the finished product. "They didn't like what they were seeing, and we were told to do a lot of retouching. This original painting showed the dog's skeleton. Norm had to go back and paint the fur on."

37 CREEPING MENACE

People had fled the cities in a mass exodus to escape the terror of the mercilous Martians. They didn't know at the time that they would not be any safer in the country or in wooded areas. The giant insects sought the hills and farm areas for food. Crossing grassy areas, the creatures often unwittingly crushed fleeing humans under their huge legs. There wasn't an obstacle that could stop the monsters. Homes were smashed to bits if they lay in the path of the on-rushing beasts. The inhabitants' only warning of peril was the crash of heavy foot-steps as the creatures approached. Their only hope for survival was to hide before the insects detected them.

©BUBBLES INC. PRTD. IN U.S.A.

SEE CARD 38
VICTIMS OF THE BUG
COLLECT THE SET OF 55 CARDS

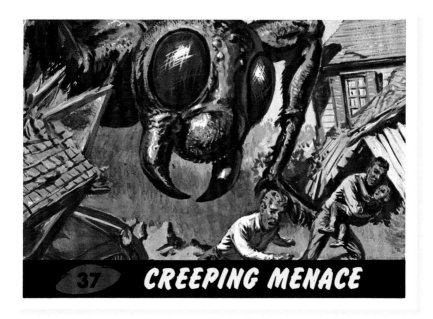

CREEPING MENACE

37

Because of their uneasiness over the material, Topps decided to release the series under the copyright "Bubbles Inc." rather than Topps, a practice begun in 1956 when they produced a trading card series based around then-controversial rocker Elvis Presley.

 38

VICTIMS OF THE BUG

Riding along a bumpy country road in their jeep, three soldiers looked up in time to see a huge flying insect heading in their direction. "Let's jump for that ditch," cried the driver as he jammed on the brakes. The men leaped out of the vehicle as the bug crashed headlong into it. Seeing that the soldiers had escaped, the monster lashed out after them into the ditch. One of the men fell under the mighty blow. The other two soldiers fought side by side, trying to overpower their assaulter. The powerful creature continued his attack, not flying from the area till it had won the battle.

SEE CARD 39
ARMY OF GIANT INSECTS
COLLECT THE SET OF 55 CARDS

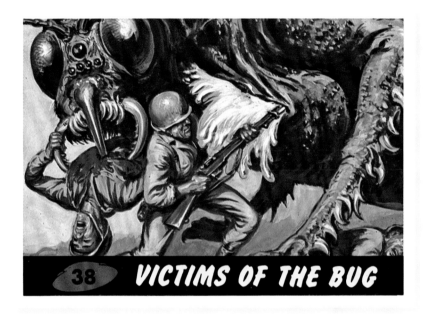

38 **VICTIMS OF THE BUG**

"One fellow who worked in our department told us, 'I think you got it all wrong—this is a world-wide invasion. All the cards should depict famous places!' By showing how individuals on the street were dealing with this, with just one or two people fighting a Martian or a monster, he thought we weren't showing the larger calamity. We were making it too small."

 ARMY OF GIANT INSECTS

Under the direction of their Martian commanders, a troop of giant insects united on a hilltop overlooking a U. S. Army camp. The weird cries of the bugs attracted the attention of the soldiers in the camp and the men quickly prepared themselves for a battle. An immense line of creatures advanced toward the military establishment. Closer and closer the insects came, until the commanding officer gave the order to open fire. Rifle and machine-gun fire crackled through the air and bullets blazed a trail of death to the insects. The towering monsters fell in their tracks as the hard-fighting soldiers won the battle.

©BUBBLES INC. PRTD. IN U.S.A.

SEE CARD 40
HIGH VOLTAGE EXECUTION
COLLECT THE SET OF 55 CARDS

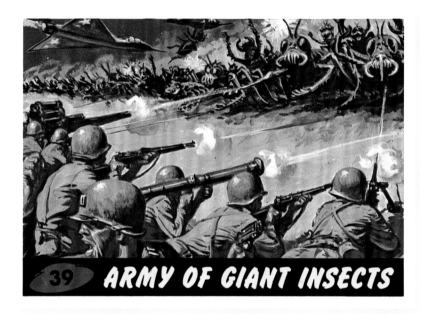

39 *ARMY OF GIANT INSECTS*

Brown and Gelman agreed that the series shouldn't show only large-scale destruction. "I think we did right by including both, how the common man—or woman, in a lot of cases—was menaced by the Martians. It didn't always have to be the Martians destroying the White House or the Golden Gate Bridge," says Brown, before adding, "but Mount Rushmore would have been neat."

 HIGH VOLTAGE EXECUTION

With military units unable to combat every giant bug around, citizens were left defenseless and at the mercy of the destructive brutes. One giant bug marched across the Texas plains, destroying a fortune in livestock and ranch homes. Planes attacked the bug, but failed to stop it as the monster plodded forward. Just on the outskirts of one of Texas' largest cities, was a hydro-electric dam which supplied most of the state's electric power. High voltage electric wires surrounded the dam. The giant bug headed straight into the death-charged wires. Sparks were shot off in every direction as the bug became entangled in the lines. The electricity destroyed the monster.

SEE CARD 41
HORROR IN PARIS
COLLECT THE SET OF 55 CARDS

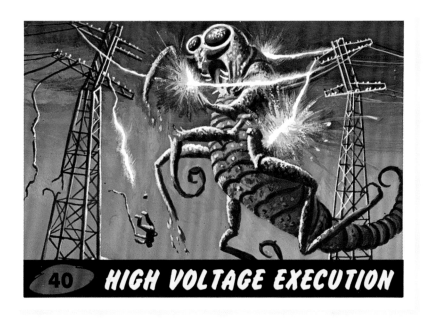

40 **HIGH VOLTAGE EXECUTION**

"I recall seeing a horror movie from the 1950s—I believe it was *War of the Colossal Beast* [1958]—which showed a sixty-foot-tall creature being electrocuted by high-voltage power lines. That scene inspired this card. If you look close, you can see a man falling from the tower. I have no idea what he was doing up there, however!"

HORROR IN PARIS

The streets of Paris were in an uproar. People screamed hysterically, running in every direction, trying to escape the monsters of destruction. Parisians watched in wide-eyed horror as gigantic insects, released from the flying saucers, twisted through the famous avenues. A huge caterpillar, more than a thousand feet long, weaved itself around the base of the famed Eiffel Tower. Slowly it writhed its way up the steel structure, intent on reaching the top of the 987 ft. site. The metal beams, which had withstood vicious hurricanes in the past, had never before been put to such a test of strength. The tower swayed to & fro, until the strain snapped it in two.

©BUBBLES INC. PRTD. IN U.S.A.

SEE CARD 42
HAIRY FIEND
COLLECT THE SET OF 55 CARDS

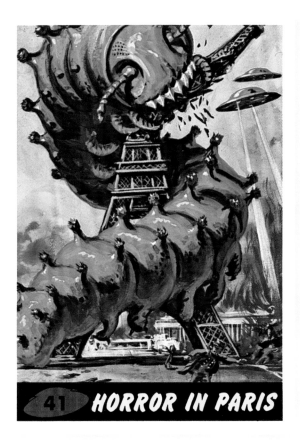

41 *HORROR IN PARIS*

Brown wrote the copy on the back of the cards for the entire series. "I had a lot of fun writing them. Even though I was causing myself trouble, I was for more copy because I was a big reader. They could have given me eight lines of copy in larger type, but I wanted more for the kids to read."

 HAIRY FIEND

The President of the United States called a special emergency meeting with his top military generals and strategists. The group gathered in a wooded hut outside a demolished Washington, D.C. Mid-way through the discussion of the plans of the counter invasion, an Army lookout dashed into the hut. "We'll have to clear the area at once. Scouts report a giant spider approaching in our direction." The President and his advisers immediately boarded helicopters and watched the soldiers fight the spider from the air. Lives were lost as the brave men tried to destroy the insect. Without the proper weapons to combat the bug, the surviving soldiers were forced to flee.

SEE CARD 43
BLASTING THE BUG
COLLECT THE SET OF 55 CARDS

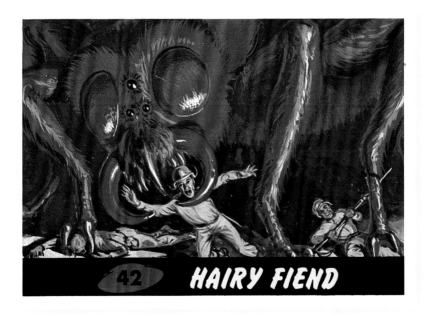

42 **HAIRY FIEND**

"I got away with a lot back in those days," Brown says. "I don't think management even bothered to read the backs. They were very worried about the artwork being offensive, but they let me write about any gruesome thing I wanted!"

43 — BLASTING THE BUG

Helicopters cruised over wooded areas, always on the lookout for giant bugs. When one was spotted, word was flashed back to the military forts giving the exact location of the insect. The fort immediately dispatched enough artillery and men to fight the menace. One monster was spotted a mile south of Fort Bragg in North Carolina. U.S. tanks surrounded the giant bug, blocking any possible escape path. A steady barrage of ammunition ripped into the insect, pushing it backwards into one of the tanks. Soldiers hurled hand-grenades at the weakened creature and they exploded the bug's heavy shell. The attack continued until the men were sure they'd destroyed the insect.

©BUBBLES INC. PRTD. IN U.S.A.

SEE CARD 44
BATTLE IN THE AIR
COLLECT THE SET OF 55 CARDS

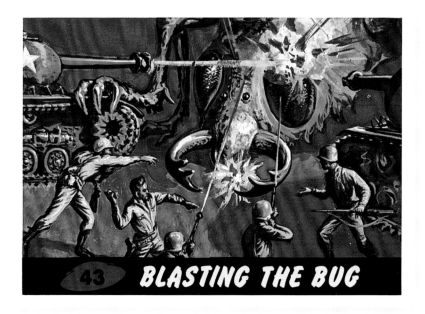

43 BLASTING THE BUG

Brown recalls that, when writing copy, "I'd have all the original paintings on my desk, going through them and writing about what I saw. It didn't take that long, because Woody and I had talked out each scenario beforehand, so I already had a lot of our little thoughts about what to say in mind before I started to write."

 BATTLE IN THE AIR

Giant winged insects flew through the skies of Earth, often grabbing terrified people off the streets and flying away with them. Huge and powerful, the monsters could crash into fleeing automobiles and overturn them without any damage to themselves. The only means of combatting the flying menaces was with helicopters. Crack shots were sent up with guns and ammunition with orders to bring down the winged terrors. Battles in the sky were common over city streets as the insects dodged the bullets to survive, and at the same time tried to ram into the helicopters. The brave men in the 'copters were in constant peril, but gallantly continued their fight.

SEE CARD 45
FIGHTING GIANT INSECTS
COLLECT THE SET OF 55 CARDS

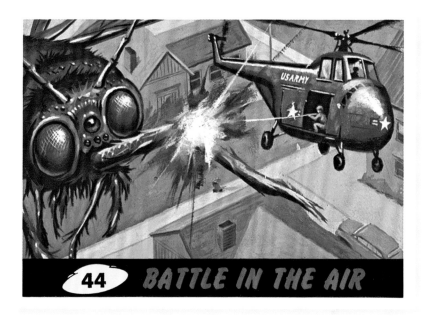

44 BATTLE IN THE AIR

"I did one and a half cards a day for Topps doing Mars Attacks," said Norm Saunders in a 1981 interview. Like most card and comics companies of the time, Topps retained the original paintings and eventually sold them off in the 1970s. "Of course, nobody knew the true value or historical significance of the art back then," says Brown.

 45 *FIGHTING GIANT INSECTS*

A jet bomber on a mission across the country saw a giant bug moving close to a populated village. The pilot flew as close to the ground as he could and released several bombs. Off target, the bombs didn't kill the bug but badly wounded it. The insect bellowed loudly in pain, terrifying the inhabitants in the near-by village. Soldiers quickly arrived on the scene and battled the crazed insect. Maddened by its wounds, the monster lashed out viciously at any moving objects near it. Bazooka shells were fired at close range, inflicting further damage to the insect. With one last furious cry, the monster turned over on its back and died.

©BUBBLES INC. PRTD. IN U.S.A.

SEE CARD 46
BLAST OFF FOR MARS
COLLECT THE SET OF 55 CARDS

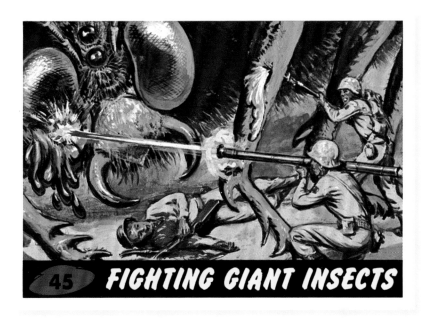

FIGHTING GIANT INSECTS
45

In recent years, a handful of original art from the series has surfaced, commanding high prices. In 2007, the original art for "The Invasion Begins" (card no. 1) sold at auction for over $80,000.

BLAST OFF FOR MARS

Military units from all over the world reported to their nearest rocket bases, which had been quickly set up by the newly formed "Space Committee." Governments from every country on Earth worked hand in hand to fight the menace from Mars. Tanks, guns, rocket-planes and soldiers were loaded into space-ships, ready to continue the vicious war with the Martians on Mars. Men from the ages of 16 to 45 were given quick physical examinations and enlisted into the Earth Army. Volunteers flooded into the recruiting centers, as brave citizens showed they were eager to fight the worst peril that had ever threatened civilization.

©BUBBLES INC. PRTD. IN U.S.A.

SEE CARD 47
EARTH BOMBS MARS
COLLECT THE SET OF 55 CARDS

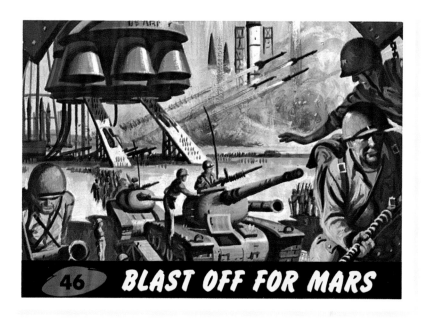

46 BLAST OFF FOR MARS

Despite its short print run, the series made an indelible impression on youngsters. In the years following its release, individual cards could sometimes still be found in penny vending machines.

 ## EARTH BOMBS MARS

The Earth spaceships were close to Mars. Hypnotized by the beauty of the planet, the soldiers were snapped back to reality by the sharpness of the commanding general's voice over the communication system. "In five minutes we will begin dropping atom bombs on Mars. We hope that these bombs will cripple any Martian resistance that we might otherwise expect." The general signed off and the soldiers rapidly reported to their assigned positions. Soon the communication system clicked on and the general spoke again.

"The Martians have set up a force field. The bombs are exploding in mid-air, before they reach the ground. Our men will have to land and fight."

GRUBBLES INC. PRTD. IN U.S.A.

SEE CARD 48
EARTHMEN LAND ON MARS
COLLECT THE SET OF 55 CARDS

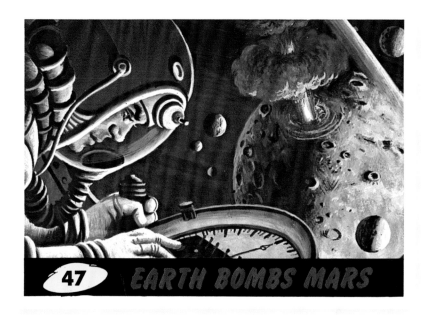

47 EARTH BOMBS MARS

The card art from the original 1962 series that appears in this volume was taken directly from the original transparencies, which still survive. The card backs were scanned from an archived set that had been kept in storage at Topps since its initial release.

48 *EARTHMEN LAND ON MARS*

The rocketships that brought the counterattack circled Mars, look-ing for a safe place to land. All the tanks and heavy artillery that would be needed to fight the Martians were aboard the spaceships. Several scouts were sent down ahead of the ships by using para-chutes or rocket-packs on their backs. Hoping to land secretly, the soldiers were startled to see several Martians wandering in the desert. Opening fire, the Earthmen blasted the Martians before they could spread an alert back to their domed cities. The Earth fighters wanted a chance to mobilize fully before the space war continued on Mars' soil. For this battle, the Earthmen wanted to make sure they were well-prepared.

SEE CARD 49
THE EARTHMEN CHARGE

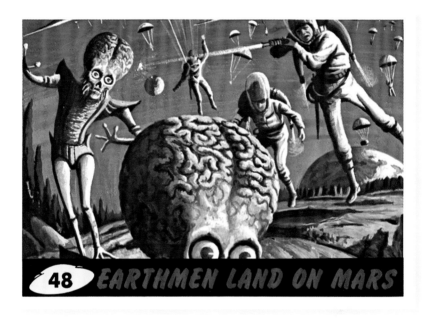

By the mid-1980s, Mars Attacks had achieved full-blown cult status, and other companies were seeking to capitalize on the phenomenon by releasing unauthorized products. Topps considered reprinting the series, and even commissioned eleven new cards, but their plans did not see fruition until 1994 (see pages 123–33).

49 THE EARTHMEN CHARGE

The Earth soldiers stormed out of their space-ships, eager to repay the Martians for the damage done to their home planet. High in spirits, the men spoke hopefully of a swift victory over the enemy. Crossing a large sand dune, the troop of soldiers suddenly stopped and stared in wonder. Sprawled across the desert sands was a magnificent domed city. The sight was breath-taking. It was evident that the Martian builders were years ahead of Earth's architects. The earthmen paused briefly, inspecting the spectacular city from the distance. The leader of the troop gave his orders and the soldiers continued toward the dome, with revenge in their hearts.

©BUBBLES INC. PRTD. IN U.S.A.

SEE CARD 50
SMASHING THE ENEMY
COLLECT THE SET OF 55 CARDS

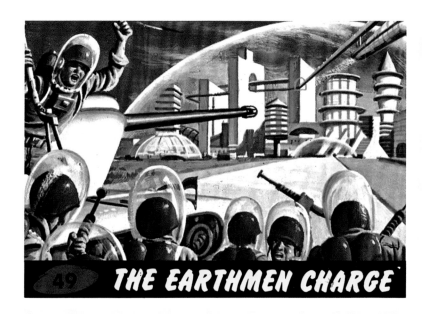

THE EARTHMEN CHARGE

Spurred by the newfound popularity of Mars Attacks, in 1987 Topps editor Gary Gerani created a spiritual successor to the series titled Dinosaurs Attack. Similar to its predecessor, Dinosaurs Attack only gained notoriety years after its original release.

 50 ## SMASHING THE ENEMY

The Earthmen fought the Martians in hand to hand combat on the outskirts of the domed city. Puny in size, the Martians weren't any match in a test of physical strength with the powerful soldiers. The Earth fighters often lifted one of the aliens over their heads and hurled them through the air. Continually pouring forward and attacking the soldiers with knives and blunt instruments, the Martians hoped to destroy their oxygen tanks. The superior fighting force won out, as the Martians were pushed further and further back into the domed city. The Earthmen knew that somewhere within the city was the Martians' power source. Their aim was to destroy the power center.

©BUBBLES INC. PRTD. IN U.S.A.

SEE CARD 51
CRUSHING THE MARTIANS
COLLECT THE SET OF 55 CARDS

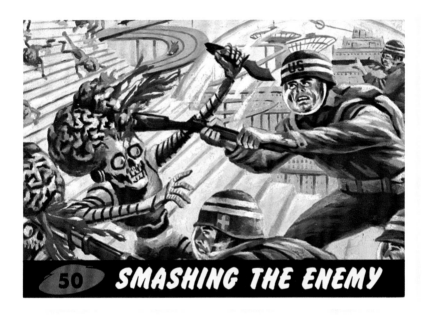

50 **SMASHING THE ENEMY**

This card shares its name with a card in the previous Topps series, Civil War News (see page 9).
Despite having used the same creative team for both series, Brown insists this was just a coincidence.

 ## CRUSHING THE MARTIANS

Across the sands of Mars rolled the powerful tanks from Earth. The tanks crashed their way into the dome city and rolled through the streets. Several Martians changed the steel vehicles with death guns aimed in their hands. Before the Martians could fire, a blast from the tank dropped them in their tracks. The tanks rolled forward, crushing anything in their path, and always heading toward the huge power source in the middle of the dome-city. The Martian scientists saw the tanks coming, but there was little they could do to protect themselves. A parade of Earthmen streamed into the power center after the tanks, smashing the equipment.

SEE CARD 52
GIANT ROBOT
COLLECT THE SET OF 55 CARDS

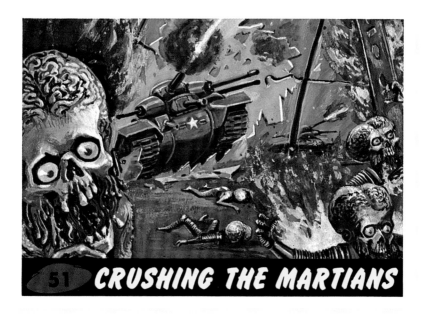

51 CRUSHING THE MARTIANS

Over the years, Mars Attacks cards have skyrocketed in value. While they originally sold for just five cents a pack, single cards in high-grade condition can command hundreds if not thousands of dollars.

GIANT ROBOT

The soldiers marched through the city, looking around at the magnificent Martian buildings with respect. The closer they inspected the structures, the more wonderous the alien technology appeared. Suddenly heavy metal footsteps echoed through the streets. Looking upward, the Earthmen saw a 50 ft. metal man rapidly stalking toward them. Without hesitating, the soldiers quickly prepared to battle the machine. Powered by remote control, the Martian monster reached down and plucked one of the fighters in its steel claws. A barrage of grenades struck the robot, sending it spinning backwards. An Army bazooka hit its mark, and the robot crumbled disabled to the ground.

SEE CARD 53
MARTIAN CITY IN RUINS
COLLECT THE SET OF 55 CARDS

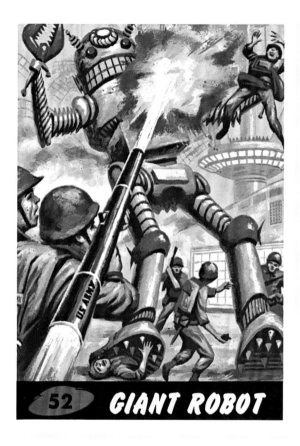

Card no. 1, "The Invasion Begins," is the rarest to find in high-grade condition. In addition to it being one of the most iconic images in the series, it is also hard to find in good condition, since card sets tended to be stacked sequentially, and the top card was most susceptible to wear and damage.

 MARTIAN CITY IN RUINS

All across the planet of Mars, the domed cities lay in ruins. Martian victims were sprawled across the desert sands, many badly wounded and others beyond repair. The advanced civilization had been beaten into the dust under the force of Earth's violent counterattack. The Martian buildings and mono-rails, which had taken years to build, were all gone. Sinister vibrations and rumbles were continually registered from the interior of the planet. The dangerous atomic pressures were rapidly building up to the climactic point and it was now only hours before the explosion which would destroy Mars. The Earth Army piled into their spaceships and left the doomed planet.

©BUBBLES INC. PRTD. IN U.S.A.

SEE CARD 54
MARS EXPLODES
COLLECT THE SET OF 55 CARDS

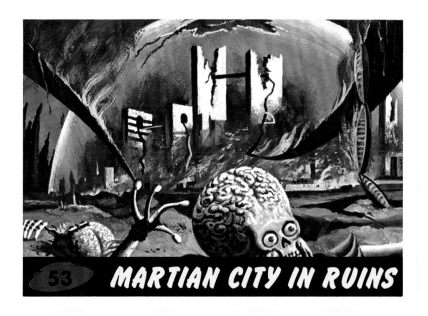

53 MARTIAN CITY IN RUINS

Norm Saunders painted a trilogy of war card series for Topps: Civil War News, Mars Attacks, and Battle (about World War II). He also contributed to such other great series as Ugly Stickers in 1965, Batman in 1966, and Wacky Packages, starting in 1967. A prolific commercial artist who painted more pulp covers than anybody else ("one hundred or more a year for twenty years, starting in 1935," he told *The Wrapper* magazine in 1981), Saunders died on March 7, 1989, at the age of eighty-two.

54 · MARS EXPLODES

The once-magnificent cities of Mars lay in burnt destruction. Earth's counterattack had completely shattered all civilization on the hostile planet. The triumphant Earthmen returned to their rocketships and took off for home. With the Martians already badly battered, the worst was yet to come. Atomic pressures in the interior of Mars, having reached a dangerous level, suddenly erupted with terrific force. The shock waves from the immense explosion rocked the space ships as they traveled back toward Earth. Before the pilot's very eyes, they watched Mars blow up into millions of tiny asteroids. **THE END.**

©BUBBLES INC. PRTD. IN U.S.A.

SEE CARD 55
COMPLETE CHECKLIST
COLLECT THE SET OF 55 CARDS

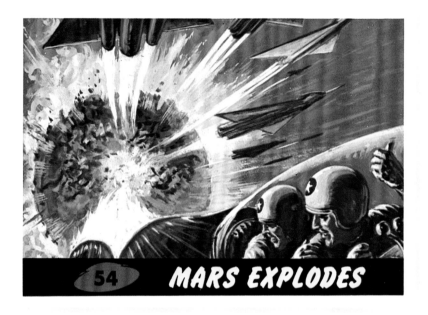

54 *MARS EXPLODES*

The destruction of Mars was an afterthought—but perhaps a foregone conclusion. "In those days, there was no thought of creating a sequel or a second card set, so we had no problem destroying every last Martian."

MARS ATTACKS!
CHECKLIST

1 ☐ The Invasion Begins	29 ☐ Death In The Shelter
2 ☐ Martians Approaching	30 ☐ Trapped!!
3 ☐ Attacking Army Base	31 ☐ Monster Reaches In
4 ☐ Saucers Blast Jets	32 ☐ Robot Terror
5 ☐ Washington In Flames	33 ☐ Removing The Victims
6 ☐ Burning Navy Ships	34 ☐ Terror In Railroad
7 ☐ Destroying Bridge	35 ☐ The Flame Throwers
8 ☐ Times Square Terror	36 ☐ Destroying A Dog
9 ☐ The Human Torch	37 ☐ Creeping Menace
10 ☐ Skyscraper Tumbles	38 ☐ Victims Of The Bug
11 ☐ "Destroy The City"	39 ☐ Army Of Insects
12 ☐ Death In The Cockpit	40 ☐ High Voltage
13 ☐ Watching From Mars	41 ☐ Horror In Paris
14 ☐ Charred By Martians	42 ☐ Hairy Fiend
15 ☐ Saucers Invade China	43 ☐ Blasting The Bug
16 ☐ Panic In Parliament	44 ☐ Battle In The Air
17 ☐ Beast And The Beauty	45 ☐ Fighting Insects
18 ☐ Soldier Fights Back	46 ☐ Blast Off For Mars
19 ☐ Burning Flesh	47 ☐ Earth Bombs Mars
20 ☐ Crushed To Death	48 ☐ Earthmen Land On Mars
21 ☐ Prize Captive	49 ☐ The Earthmen Charge
22 ☐ Burning Cattle	50 ☐ Smashing The Enemy
23 ☐ The Frost Ray	51 ☐ Crushing The Martians
24 ☐ The Shrinking Ray	52 ☐ Giant Robot
25 ☐ Capturing a Martian	53 ☐ Martian City In Ruins
26 ☐ The Tidal Wave	54 ☐ Mars Explodes
27 ☐ The Giant Flies	55 ☐ Checklist
28 ☐ Helpless Victim	

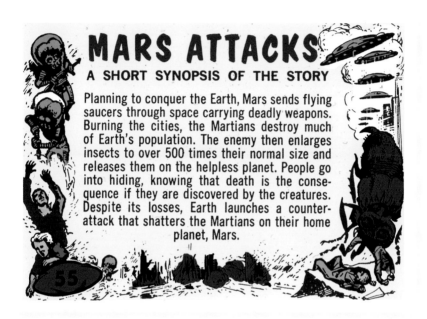

The images shown on pages 11 and 224 are no illusion. Loaned to Topps by a collector for this book, what you see is the only known sealed pack of Mars Attacks trading cards to have surfaced.

VISIONS:
NEW AND ORIGINAL

Zina Saunders

In 1994, two years before the Tim Burton/Warner Bros. movie, Topps released a second series of Mars Attacks cards. Officially titled Mars Attacks Archives, the set consisted of a reprint of the classic fifty-five-card series from 1962, as well as eleven paintings by Herb Trimpe and Earl Norem (cards 56–66 on pages 123–33), which were commissioned in 1989, based on unused concepts from Bob Powell and Wally Wood. Card copy was by Len Brown, who had also written the backs for the original 1962 series.

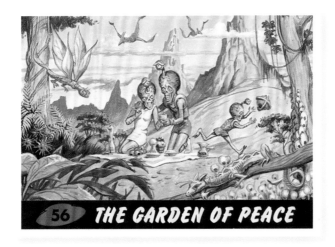

56 THE GARDEN OF PEACE

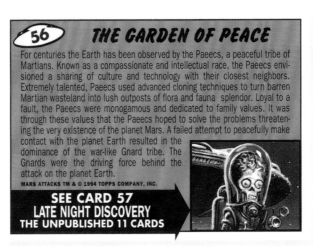

56 THE GARDEN OF PEACE

For centuries the Earth has been observed by the Paeecs, a peaceful tribe of Martians. Known as a compassionate and intellectual race, the Paeecs envisioned a sharing of culture and technology with their closest neighbors. Extremely talented, Paeecs used advanced cloning techniques to turn barren Martian wasteland into lush outposts of flora and fauna splendor. Loyal to a fault, the Paeecs were monogamous and dedicated to family values. It was through these values that the Paeecs hoped to solve the problems threatening the very existence of the planet Mars. A failed attempt to peacefully make contact with the planet Earth resulted in the dominance of the war-like Gnard tribe. The Gnards were the driving force behind the attack on the planet Earth.

MARS ATTACKS TM & © 1994 TOPPS COMPANY, INC.

SEE CARD 57
LATE NIGHT DISCOVERY
THE UNPUBLISHED 11 CARDS

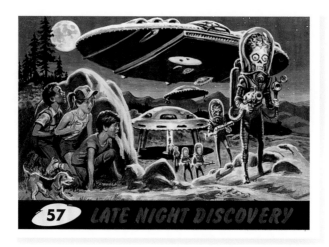

LATE NIGHT DISCOVERY

The mighty Martian assault force systematically scouted large sections of unpopulated countryside. The barren, open areas served as strategic points to amass large assault forces as well as serving as refueling ports away from prying eyes. The element of surprise was essential to the Martians' plans for world dominance. The advance scouts moved as quietly as the hushed saucers that made no noise as they landed in the grassy valley. This night there would be no witnesses to the beginning assault as strict orders were carried out – kill every Earthling that you encounter so that the secret arrival of the Martians will be ensured!

SEE CARD 58
THE LAST PICTURE SHOW
THE UNPUBLISHED 11 CARDS

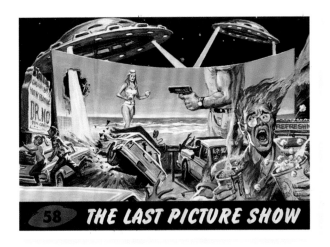

58 THE LAST PICTURE SHOW

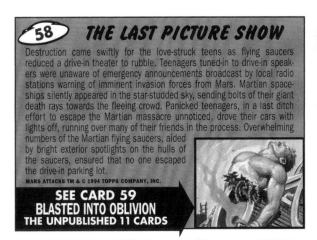

58 THE LAST PICTURE SHOW

Destruction came swiftly for the love-struck teens as flying saucers reduced a drive-in theater to rubble. Teenagers tuned-in to drive-in speakers were unaware of emergency announcements broadcast by local radio stations warning of imminent invasion forces from Mars. Martian spaceships silently appeared in the star-studded sky, sending bolts of their giant death rays towards the fleeing crowd. Panicked teenagers, in a last ditch effort to escape the Martian massacre unnoticed, drove their cars with lights off, running over many of their friends in the process. Overwhelming numbers of the Martian flying saucers, aided by bright exterior spotlights on the hulls of the saucers, ensured that no one escaped the drive-in parking lot.

MARS ATTACKS TM & © 1994 TOPPS COMPANY, INC.

SEE CARD 59
BLASTED INTO OBLIVION
THE UNPUBLISHED 11 CARDS

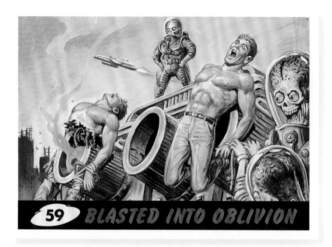

59 BLASTED INTO OBLIVION

 BLASTED INTO OBLIVION

Quoting from a captured Martian Invasion Handbook, "A dead Earthling is a good Earthling," Martians had little use for prisoners. Because of the language barrier between the two races, new information from prisoners was impossible to obtain. Instead, Martians gleefully tied prisoners, usually brave army soldiers, to the exhaust ports of their land assault vehicles. Many a brave man died for his planet as the switch was thrown activating the thrust of solar-powered engines. Martian leaders, gleefully aware of the panic factor in such executions, used hidden cameras equipped with sophisticated broadcasting devices to telecast their atrocities to the Earth's major networks. The President of the United States ordered the television signals jammed, but millions of viewers in Europe and Asia were exposed to the horrors of the Martian invaders.

MARS ATTACKS TM & © 1994 TOPPS COMPANY, INC.

SEE CARD 60
UNSPEAKABLE EXPERIMENTS
THE UNPUBLISHED 11 CARDS

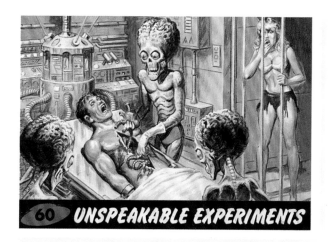

 UNSPEAKABLE EXPERIMENTS

Having studied the inhabitants of the Earth from afar for centuries, the Martians now had the opportunity to learn more about the Earthmen first hand. Captured victims were beamed aboard a flying saucer where a Martian laboratory had been set up to study the physiological make-up of the Earthlings. While some of the equipment was advanced Martian technology, there were also some unfortunate shortcomings in the laboratories. A most serious and painful one was the fact that no form of anesthesia existed on Mars. Therefore the painful experiments rivaled the most horrific tortures of mankind's history. One kidnapped victim of vivisection lived barely long enough to see his beating heart torn from his open chest cavity.

With his dying breath he heard his wife screaming in horror as she watched helplessly . . . knowing she would be the next victim of the sadistic scientists.

MARS ATTACKS TM & © 1994 TOPPS COMPANY, INC.

SEE CARD 61
FLIGHT OF THE DOOMED
THE UNPUBLISHED 11 CARDS

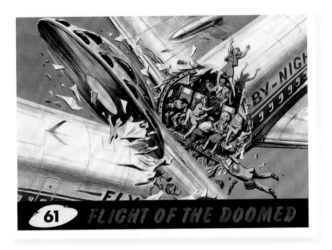

61 *FLIGHT OF THE DOOMED*

FLIGHT OF THE DOOMED

By a direct order of the President of the United States, all non-essential commercial flights were canceled. Due to direct hits by Martian forces on strategic air force bases, aviation fuel had become in very short supply. All remaining fuel was to be conserved for use by the U.S. Army jet fighters in combatting the Martian invaders in direct air to air assaults. The last commercial airliner to fly, Flight 509 to Hawaii and full of reveling holiday vacationers, met with disaster just minutes from its scheduled landing. A Martian flying saucer, just launched from its secret base inside of an extinct Hawaiian volcano, sliced through the plane fuselage like a hot knife through butter. All 207 passengers, including 48 women and 42 children, were killed.

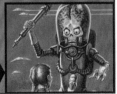

SEE CARD 62
LAST LICKS
THE UNPUBLISHED 11 CARDS

62 LAST LICKS

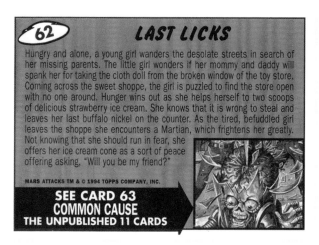

62 LAST LICKS

Hungry and alone, a young girl wanders the desolate streets in search of her missing parents. The little girl wonders if her mommy and daddy will spank her for taking the cloth doll from the broken window of the toy store. Coming across the sweet shoppe, the girl is puzzled to find the store open with no one around. Hunger wins out as she helps herself to two scoops of delicious strawberry ice cream. She knows that it is wrong to steal and leaves her last buffalo nickel on the counter. As the tired, befuddled girl leaves the shoppe she encounters a Martian, which frightens her greatly. Not knowing that she should run in fear, she offers her ice cream cone as a sort of peace offering asking, "Will you be my friend?"

MARS ATTACKS TM & © 1994 TOPPS COMPANY, INC.

SEE CARD 63
COMMON CAUSE
THE UNPUBLISHED 11 CARDS

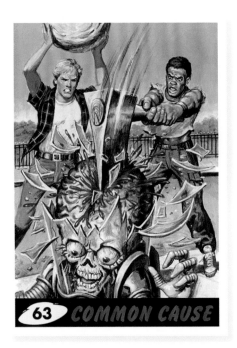

63 COMMON CAUSE

COMMON CAUSE

Before the Martian invasion, warring gangs roamed the streets of New York City. Bloodshed was a common sight as factions clashed for no other reason than the colors of their skin were different! Being the wrong color on the wrong side of the street brought out tensions which boiled over. When the Martians attacked, the gangs realized that there no longer was a right or wrong side of the street. A truce, brought about by the gang leaders, united all gangs regardless of race or color against a common threat – the destruction of the human race by a Martian invasion force. Knives, chains, axes, and rocks, once handy weapons used by humans against humans, were now used against a common foe.

For the first time gangs banded together to repel this invasion of their turf. How long the truce would last was anyone's guess. They just knew that it would last long enough to fight back against the Martians.

MARS ATTACKS TM & © 1994 TOPPS COMPANY, INC.

SEE CARD 64
SLAUGHTER IN THE SUBURBS
THE UNPUBLISHED 11 CARDS

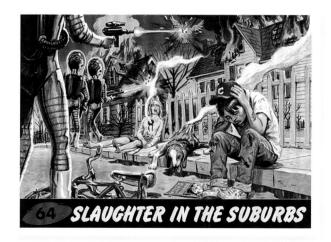

SLAUGHTER IN THE SUBURBS

64

SLAUGHTER IN THE SUBURBS

Following the swift and utter destruction of Earth's major cities, Martian leaders ordered their death squads to spread fear and death into the suburbs. Like every other Saturday, a boy and his sister, along with their faithful dog, made the trip to their local five and dime store. A pocket full of change was traded for bubble gum, trading cards, and comic books, all the things that made being ten years old fun. This Saturday, however, was different as Martian hit squads used atomic powered ray guns and solar powered flame throwers to destroy everything in their path. More horrific than any science fiction story ever imagined in a comic book, the Martians had arrived in the suburbs!

MARS ATTACKS TM & © 1994 TOPPS COMPANY, INC.

SEE CARD 65
NAKED AND THE DEAD
THE UNPUBLISHED 11 CARDS

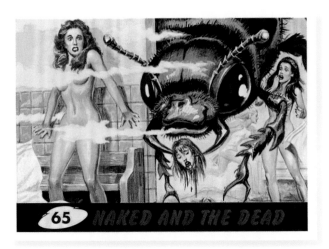

65 **NAKED AND THE DEAD**

65 **NAKED AND THE DEAD**

Mutated insects, enlarged hundreds of times by Martian scientists, swarmed over the Earth in search of breeding grounds. Damp, dark corners made ideal nesting areas in which these slimy, vile insects laid thousands of fertile eggs. A bevy of coeds accidentally stumbled upon one such nesting ground in the women's locker room showers. The giant insect, in an effort to protect her hatching brood, used her massive mandibles and sharp teeth to eliminate her victims. Coeds that would have shrieked at the sight of the insect even at its normal size ran in blind terror, falling victim to the enlarged insect's decapitating pinchers.

MARS ATTACKS TM & © 1994 TOPPS COMPANY, INC.

SEE CARD 66
VICTORY ON MARS
THE UNPUBLISHED 11 CARDS

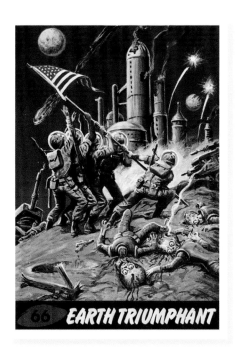

66 EARTH TRIUMPHANT

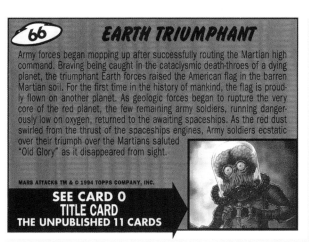

66 EARTH TRIUMPHANT

Army forces began mopping up after successfully routing the Martian high command. Braving being caught in the cataclysmic death-throes of a dying planet, the triumphant Earth forces raised the American flag in the barren Martian soil. For the first time in the history of mankind, the flag is proudly flown on another planet. As geologic forces began to rupture the very core of the red planet, the few remaining army soldiers, running dangerously low on oxygen, returned to the awaiting spaceships. As the red dust swirled from the thrust of the spaceships engines, Army soldiers ecstatic over their triumph over the Martians saluted "Old Glory" as it disappeared from sight.

MARS ATTACKS TM & © 1994 TOPPS COMPANY, INC.

**SEE CARD 0
TITLE CARD
THE UNPUBLISHED 11 CARDS**

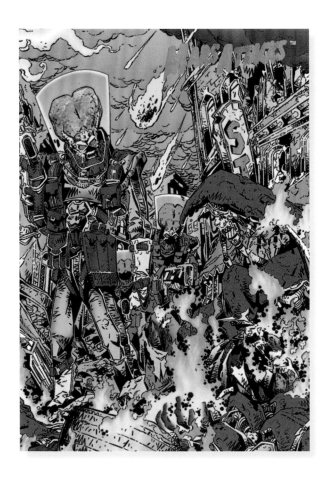

By 1994, Topps was producing their own comic books as well
as a variety of painted trading cards, and pulled together from their
stable of artists a new thirty-two-card subset titled Visions: New and
Original (starting on this page through page 166.)

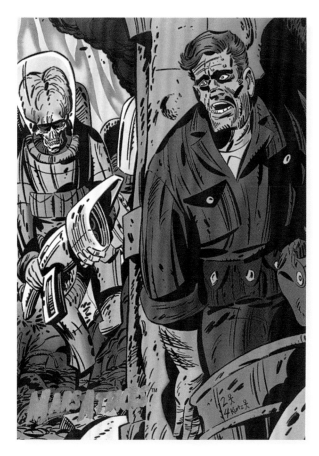

Above and opposite: Keith Giffen

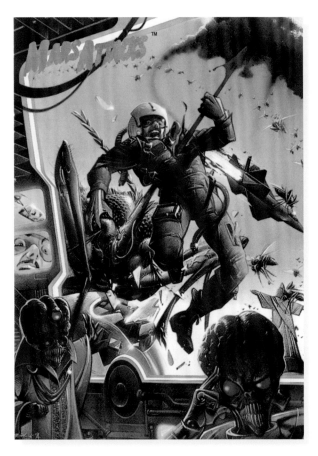

Ken Steacy

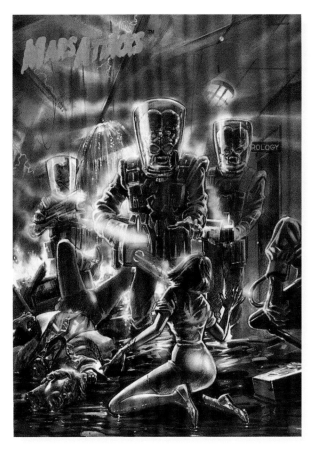

Ted Boonthanakit

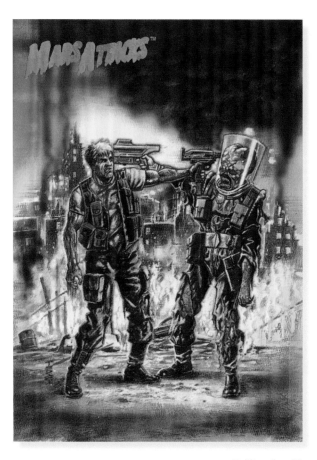

Ted Boonthanakit

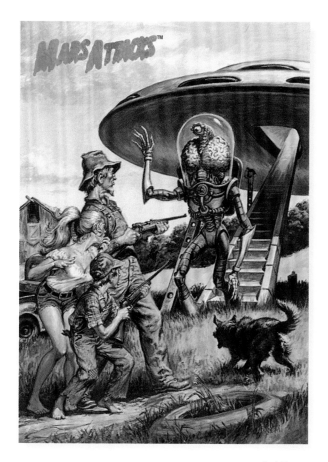

Earl Norem

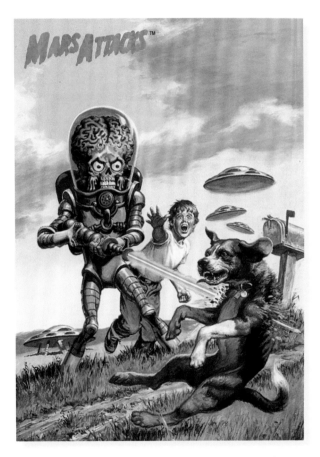

Earl Norem

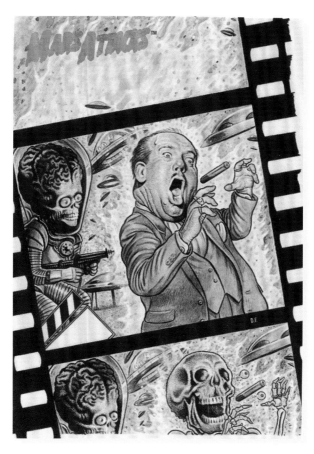

Drew Friedman

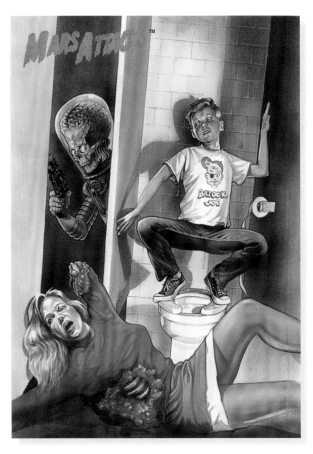

Zina Saunders

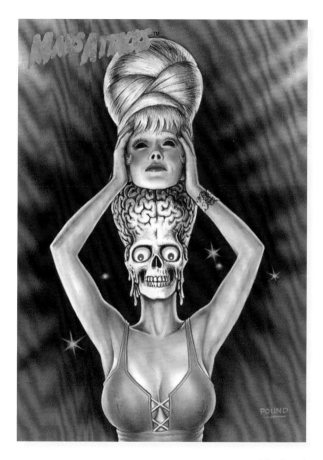

John Pound

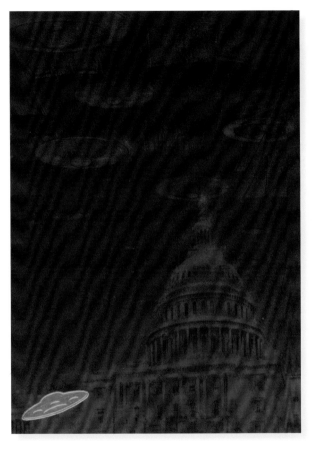

Charlie Adlard

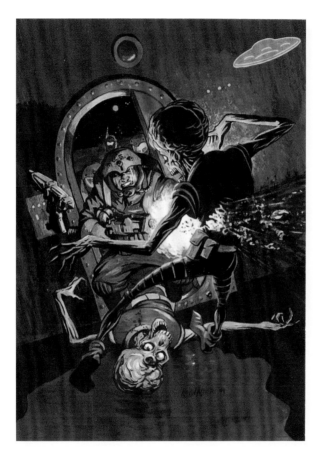

Kevin Altieri

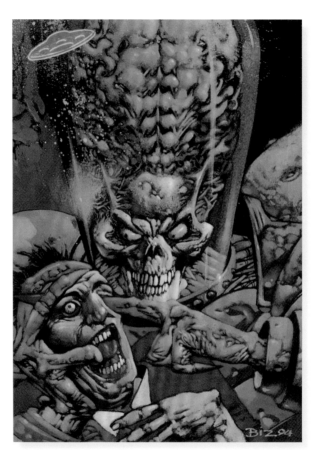

Simon Bisley

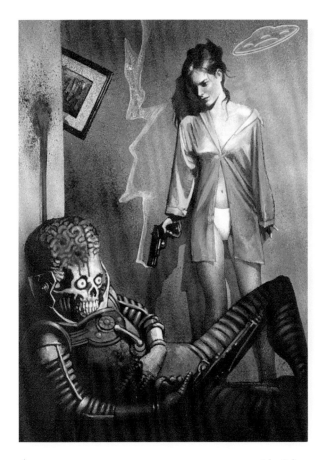

John Bolton

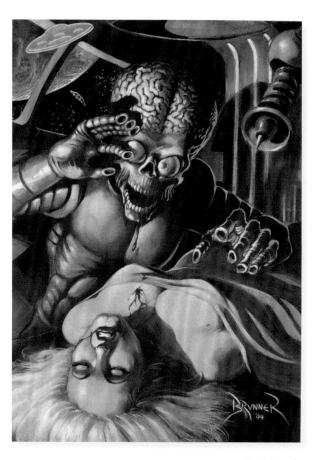

Frank Brunner

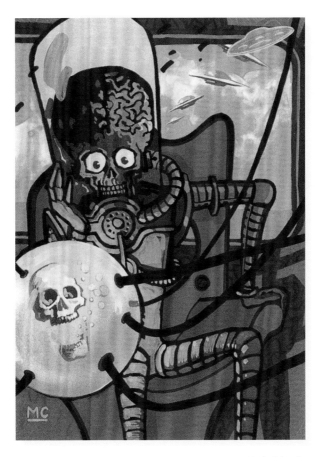

Mark Chiarello

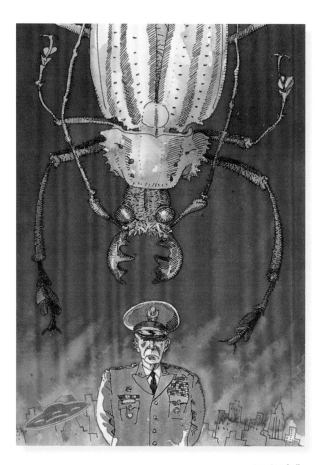

Joe Ciardiello

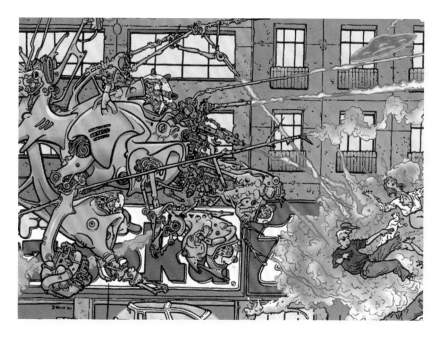

Geof Darrow

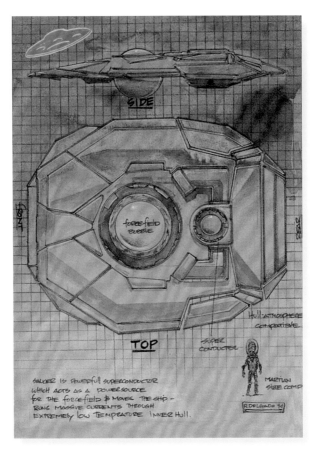

SIDE

FRONT

forcefield
bubble

REAR

TOP

SUPER
CONDUCTOR

Hull-atmosphere
compartment

MARTIAN
SIZE COMP.

R DELGADO 91

SAUCER IS POWERFULL SUPERCONDUCTOR
WHICH ACTS AS A POWERSOURCE
FOR THE forcefield TO MOVES THE SHIP —
RUNS MASSIVE CURRENTS THROUGH
EXTREMELY LOW TEMPERATURE INNER HULL.

Ricardo Delgado

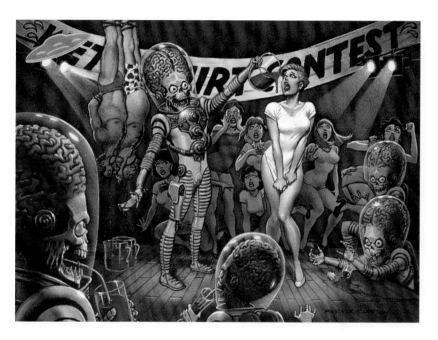

Steve Fastner and Rich Larsen

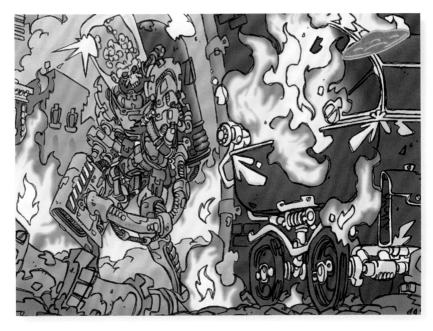

Keith Giffen

Sam Kieth

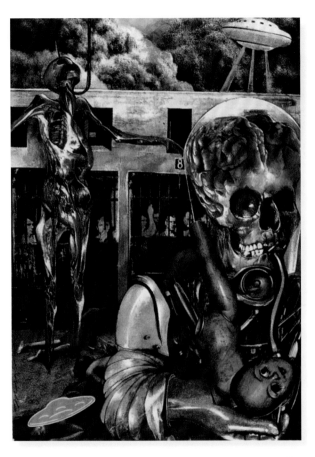

Miran Kim

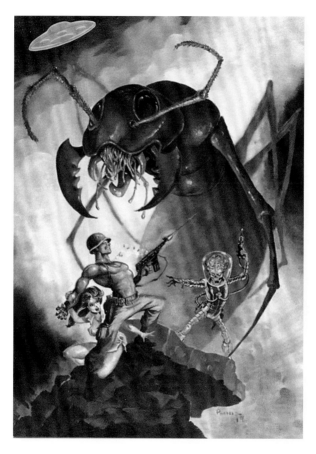

Michael Ploog

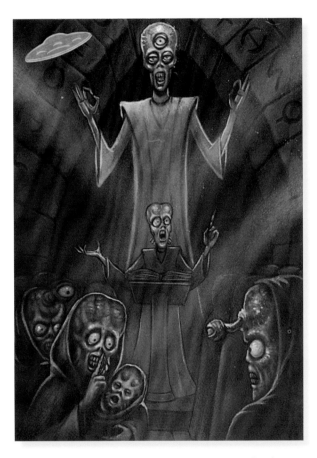

John Rheaume

Zina Saunders

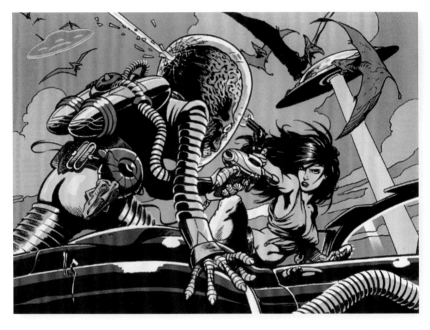

Mark Schultz

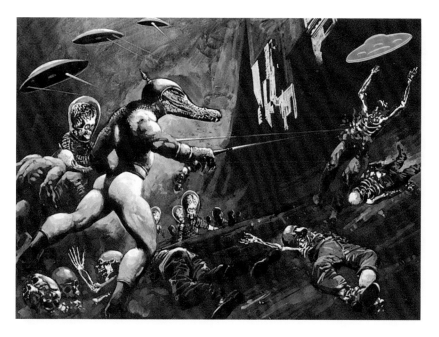

Joe Smith

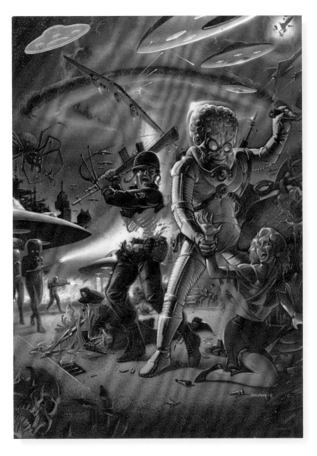

Ken Steacy

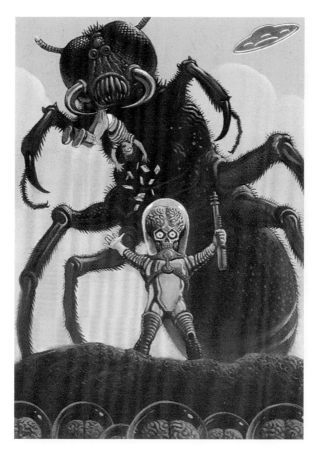

William Stout

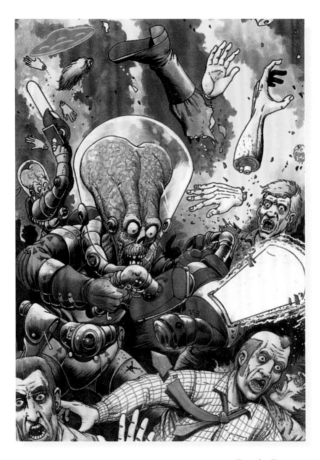

Timothy Truman

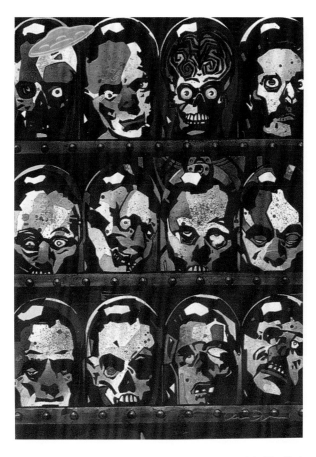

John Van Fleet

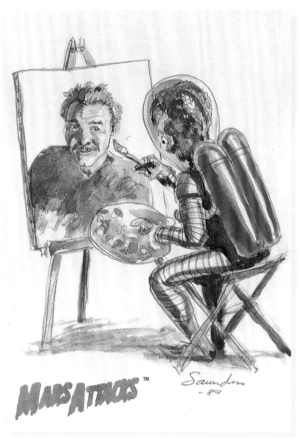

Norm Saunders

THE WORLD OF MARS ATTACKS

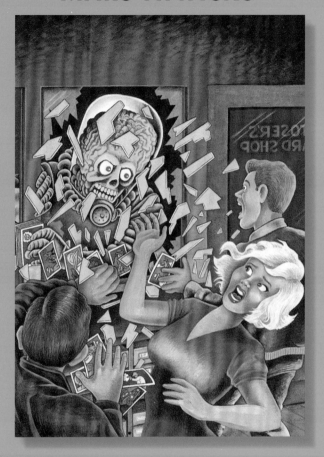

Over the years, a variety of Mars Attacks cards have been produced by Topps for a number of different companies. Above is a card from *Non-Sport Update* (July–August 1994), illustrated by Garbage Pail Kids artist Jay Lynch. Exclusive tie-in cards from Screamin' Products models, Pocket Comics, and others are collected here for the first time (pages 167–81).

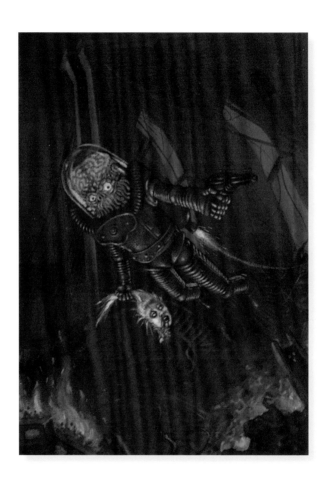

"Air Assault Martian" by Rob Robison. Screamin' Products model, 1995.

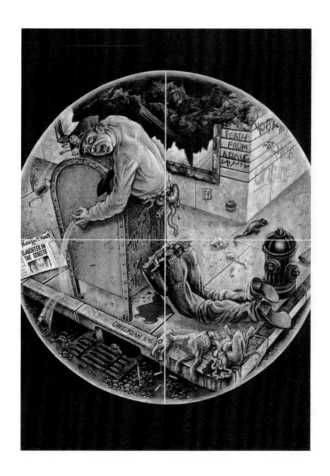

"Slaughter in the Streets" by Chris Ryan. Screamin' Products model, 1995.

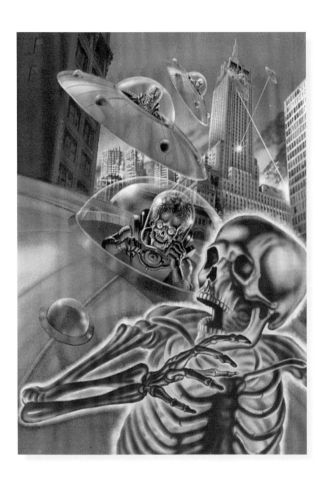

"Terror in the Sky" by Ed Repka. Screamin' Products model, 1995.

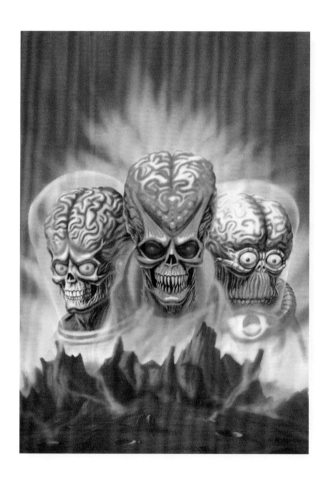

"The Invasion Begins" by Ed Repka. Screamin' Products model, 1995.

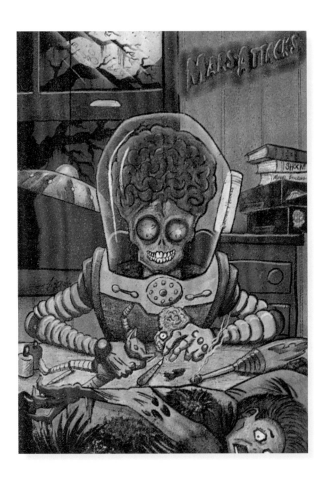

"Mars Attacks Modeling" by John G. Gernon. Screamin' Products
model, 1995.

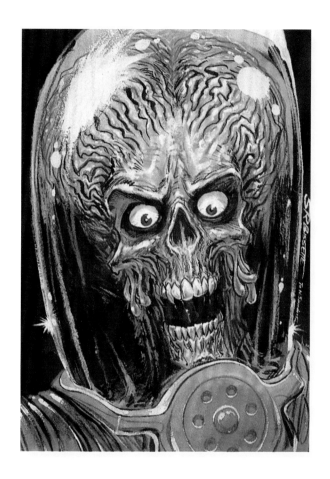

"Attacking Martian" by Steve Bissette. Screamin' Products model, 1995.

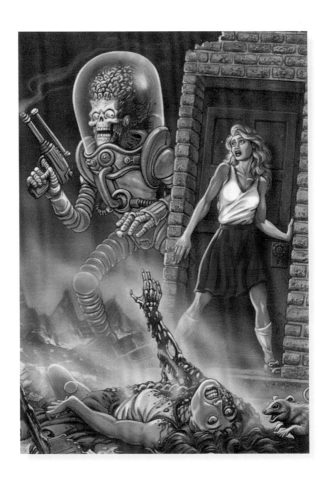

"No Place to Hide" by Jim Groman. Screamin' Products model, 1995.

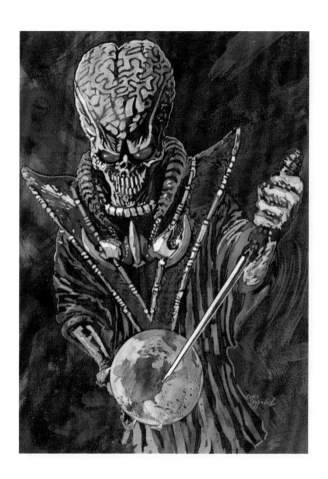

"Target Earth" by Cathy Diefendorf. Screamin' Products model, 1995.

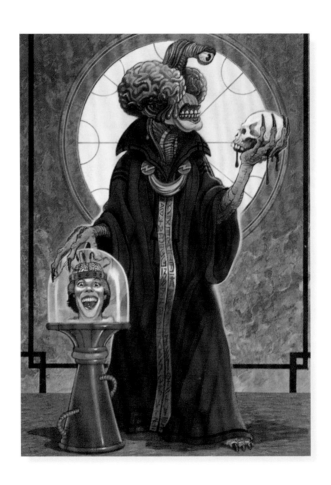

"Contemplating Conquest" by Jim Elliot. Screamin' Products model, 1995.

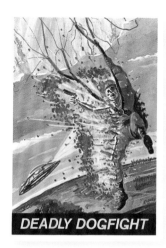

DEADLY DOGFIGHT

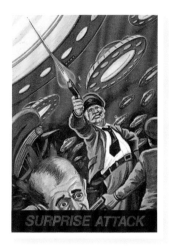

SURPRISE ATTACK

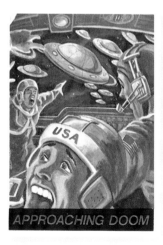

APPROACHING DOOM

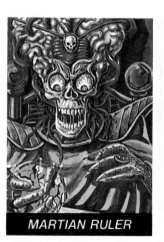

MARTIAN RULER

Exclusive trading cards by Gus LaMonica for Pocket Comics, 1988. Fifty-four were planned, but the series was canceled after four issues.

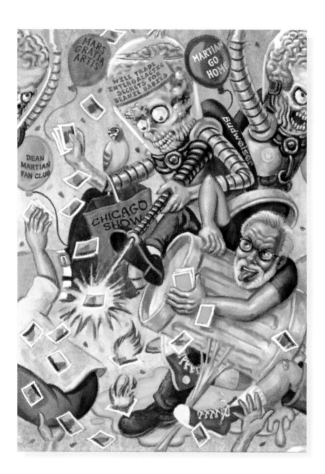

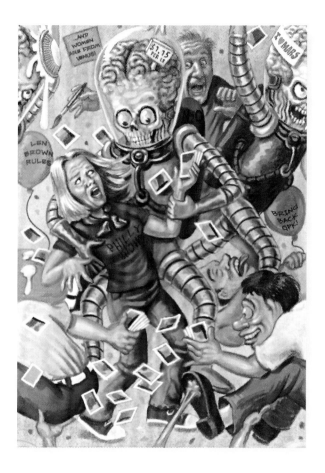

Promo cards designed by Jay Lynch and painted by Zina Saunders, 2002. Produced for the Midwest Non-Sport Trading Card Show and the Philly Non-Sports Card Show, the cards were ingeniously designed so that the two images could fit together from any direction ad infinitum. Both Lynch and Saunders are featured alongside the Martians. Norm Saunders, Zina's father, is depicted at the top of the card above.

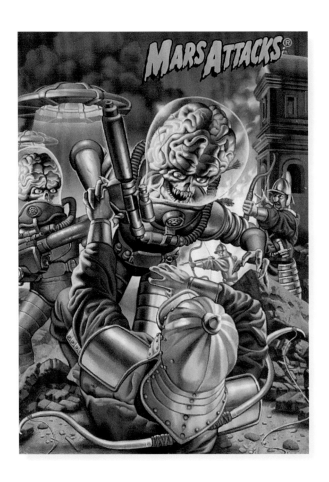

"War Dogs of the Golden Horde" by Peter Scanlan. Del Rey Books, 1997.

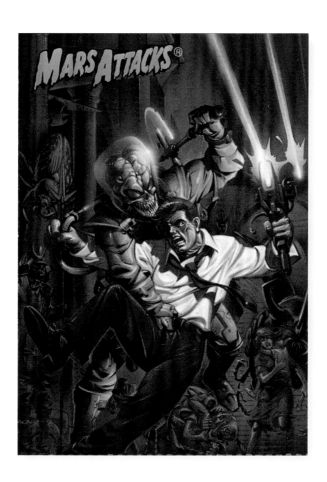

"Martian Deathtrap" by Ken Steacy. Del Rey Books, 1997.

BEHIND THE SCENES AND MORE

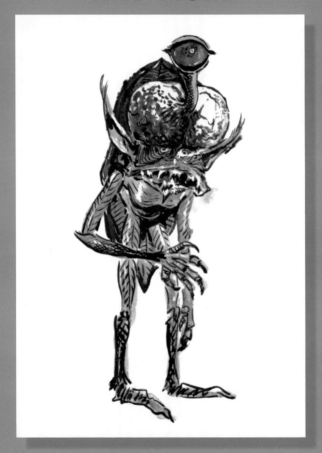

During the development of Mars Attacks, illustrators Wally Wood and Bob Powell produced hundreds of drawings, many of which are lost to history. Some development sketches have survived, including the early Martian concept designs above, opposite, and on page 184.

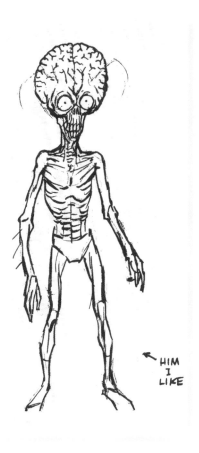

HIM
I
LIKE

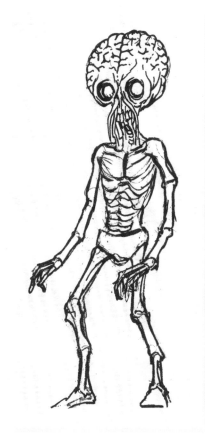

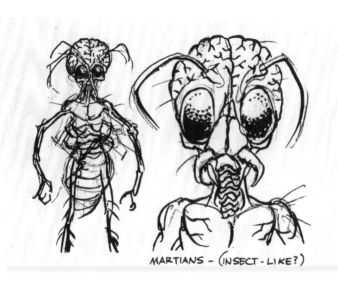

MARTIANS - (INSECT-LIKE?)

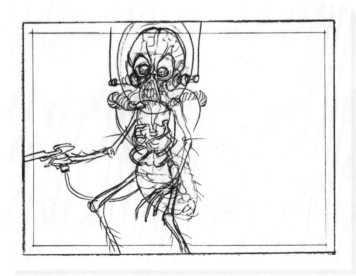

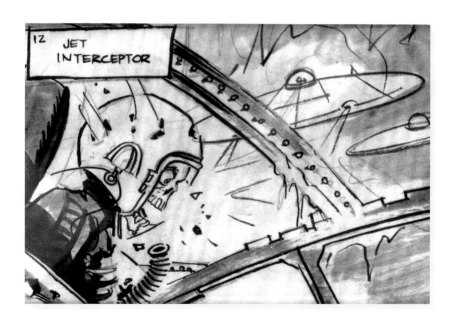

"Jet Interceptor." Previously unpublished development sketch by Wally Wood. This concept would eventually become "Death in the Cockpit" (card no. 12, page 35). Donated from a private collection.

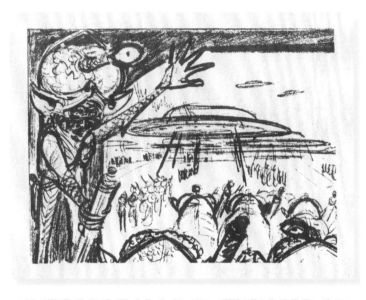

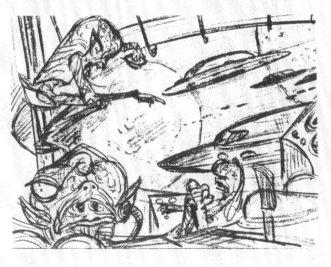

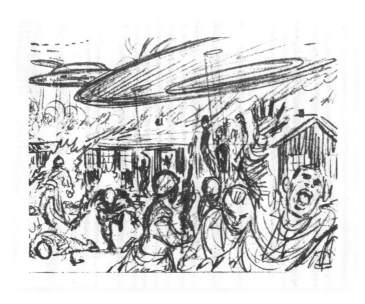

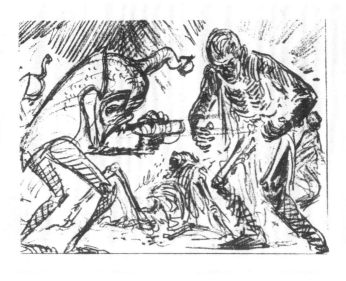

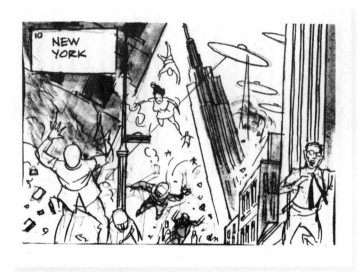

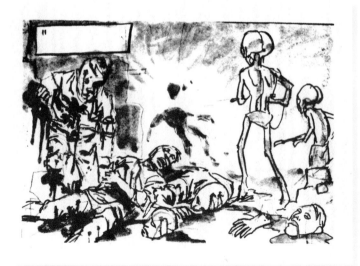

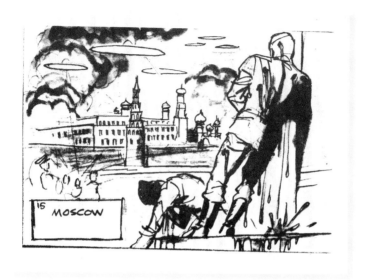

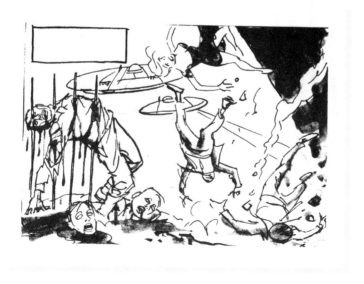

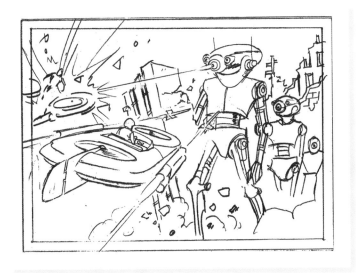

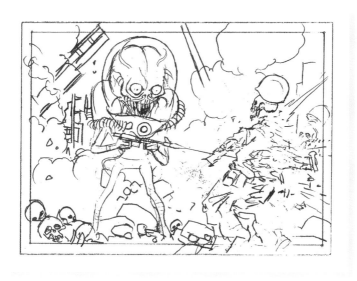

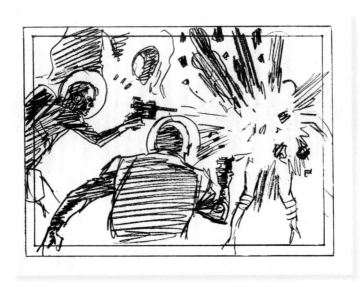

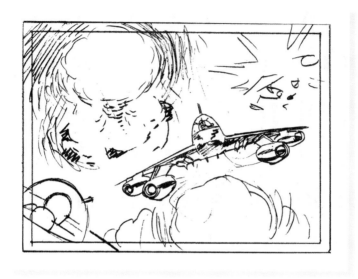

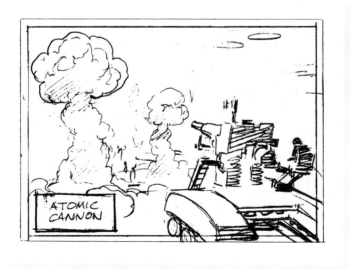

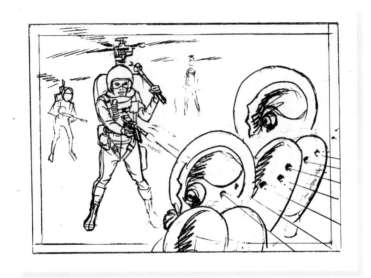

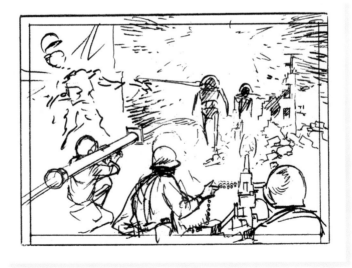

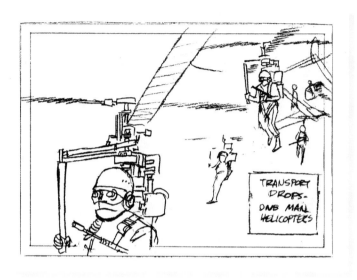

TRANSPORT
DROPS-
ONE MAN
HELICOPTERS

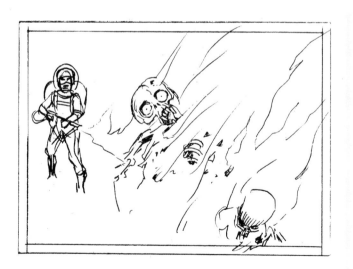

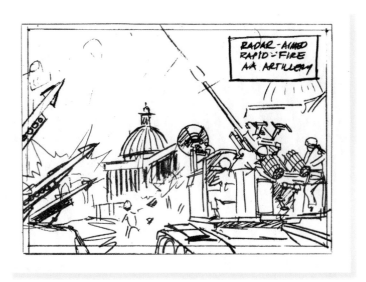

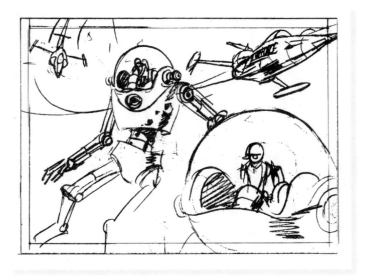

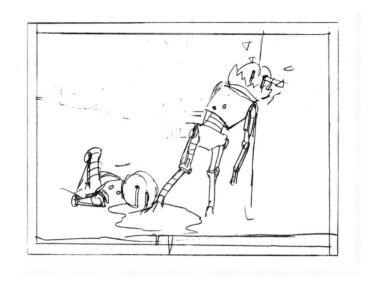

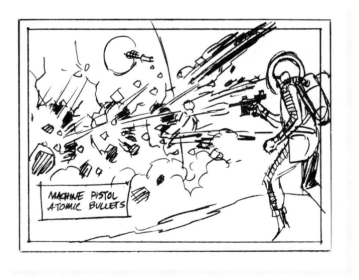

MACHINE PISTOL
ATOMIC BULLETS

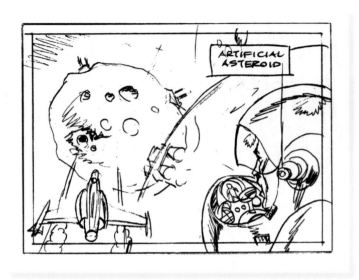

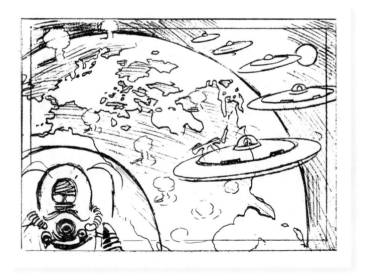

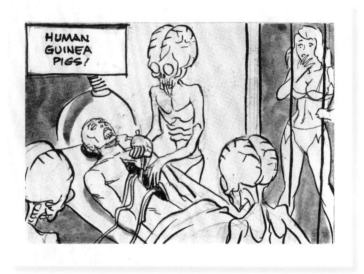

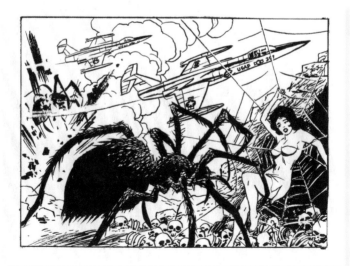

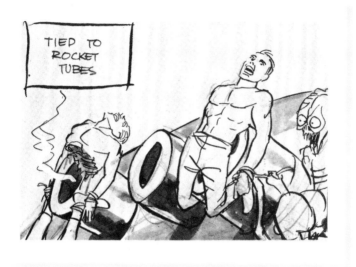

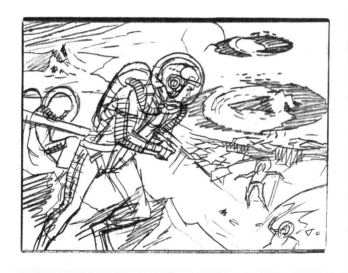

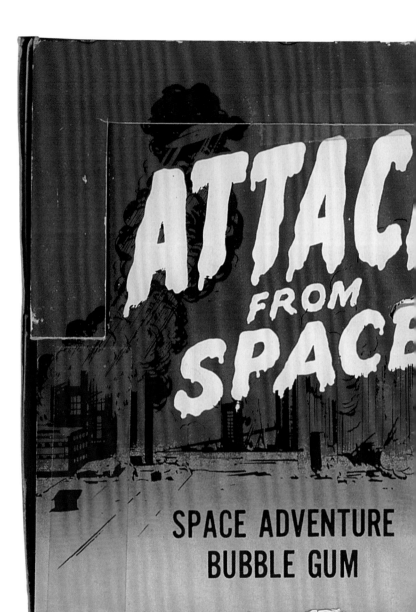

ATTACK
FROM
SPACE

SPACE ADVENTURE
BUBBLE GUM

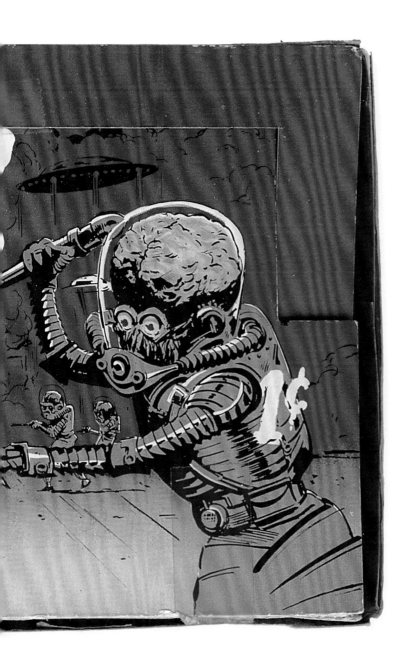

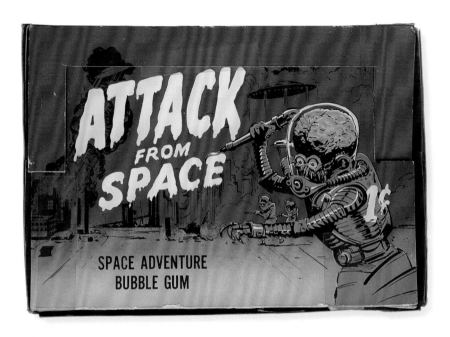

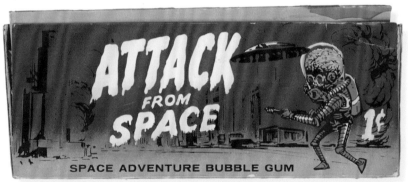

Before it was called Mars Attacks, the series was test-marketed as Attack from Space. Previous pages and above: A rare one-cent display box.

Uncut Attack from Space card wrapper.

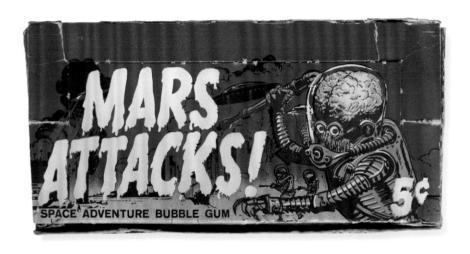

Mars Attacks display box.

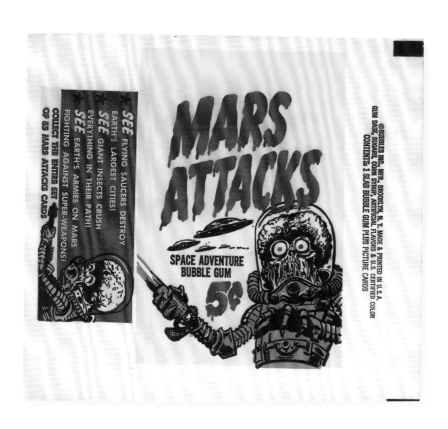

Mars Attacks card wrapper.

Uncut Mars Attacks UK edition card wrapper.

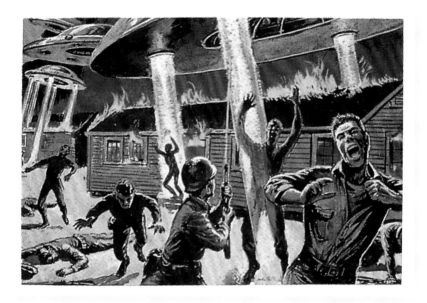

No. 3, "Attacking an Army Base"

Following public backlash after the release of Mars Attacks in 1962, Topps toyed with the idea of releasing a more toned-down, less offensive set, reportedly asking the original artists to retouch the offending images on several cards to remove the excessive gore and sexual overtones. Although the project was never completed, thirteen of the altered paintings eventually saw publication in 1984 when Rosem Enterprises released them as Mars Attacks—The Unpublished Version (pages 209–21).

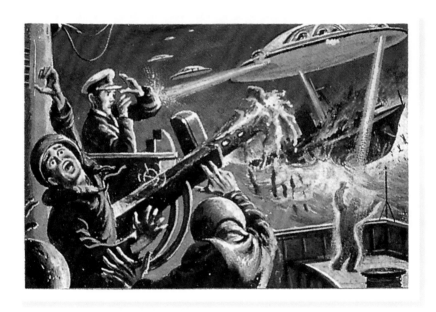

No. 6, "Burning Navy Ships"

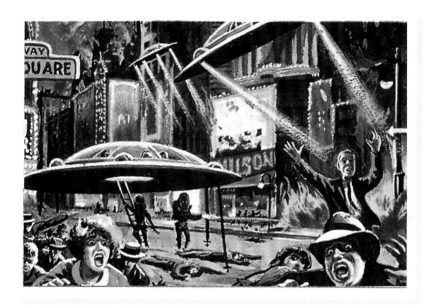

No. 8, "Terror in Times Square"

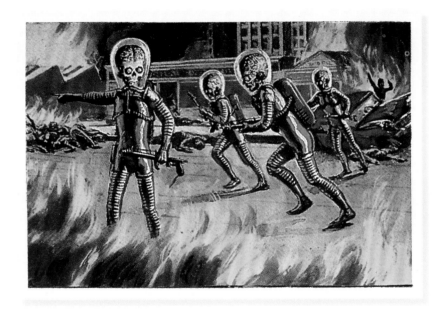

No. 11, "Destroy the City"

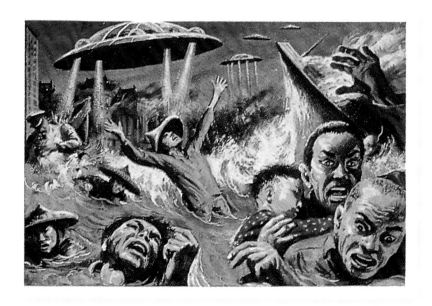

No. 15, "Saucers Invade China"

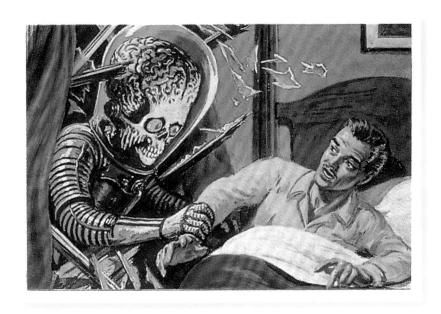

No. 17, "Beast and the Beauty"

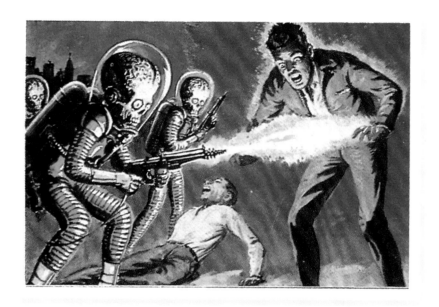

No. 19, "Burning Flesh"

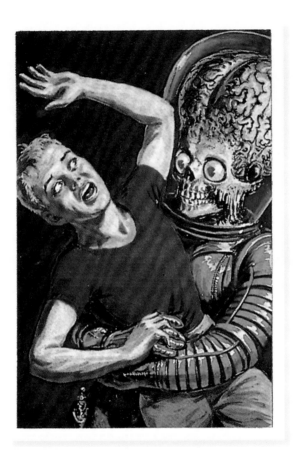

No. 21, "Prize Captive"

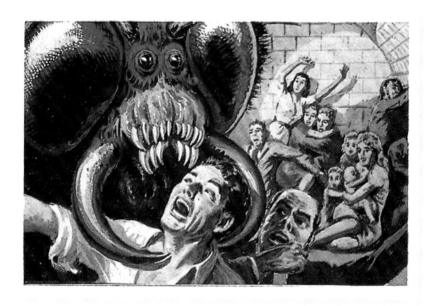

No. 29, "Death in the Shelter"

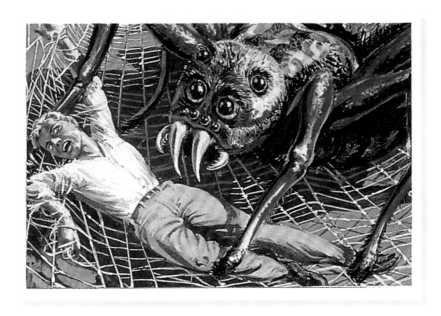

No. 30, "Trapped!!"

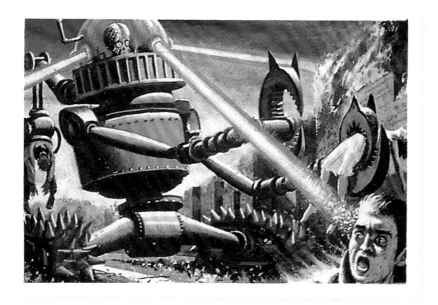

No. 32, "Robot Terror"

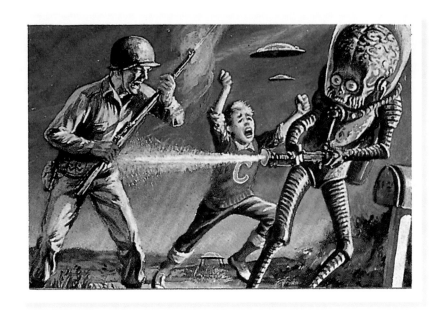

No. 36, "Destroying a Dog"

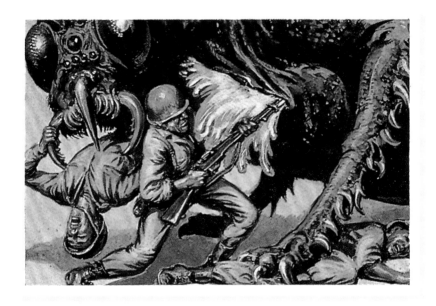

No. 38, "Victims of the Bug"

THE PERFECT ARTIST

by ZINA SAUNDERS

Dad painted Mars Attacks when I was about nine, at the same time he was becoming a real person to me. It was then that I began to actually know my father as someone other than the grown-up who bossed me around and sang a jazzy bedtime-lullaby version of "Three Little Fishes" while bobbing his cigarette in the dark of the bedroom I shared with my little brother.

My father began to have a personality separate from what he imposed on me, and I began to listen to his opinions as something other than orders from on high. He had no shortage of opinions; my father was all opinions, all the time. For example, the civil rights movement: he was for it. Religion: he was against it. And, of course, most pertinent to this book, Mars Attacks: just a bunch of bug-eyed monsters he painted for bubble-gum cards.

Dad had a brash personality. He was talkative and flamboyant, and he had a deep appreciation for—and commitment to—irreverence, and a very strong appreciation for the funny and fierce stuff of which people are composed. And he thought children were very much people. We weren't tiny angels who didn't know how to tell a lie. We weren't small cardboard figures who only had sugary syrup sloshing around in our heads. Dad knew damn well that we were ferocious little warriors, bloodthirsty and cruel, and delighted by horror.

In other words, Dad was the perfect artist for Mars Attacks.

His studio was on the third floor of the brownstone we lived in on the Upper West Side of Manhattan. In the same room was our one and only TV, so I was often sitting there watching Soupy Sales or Sonny Fox while just a few feet away Dad was wreaking death and destruction on the human race.

Dad worked at a drawing table he bought at the estate auction of one of his illustration heroes, J. C. Leyendecker. He would sit on a tall stool with a splintered and tattered straw seat covered by a threadbare folded-up towel. Wearing a green eyeshade, he painted with a magnifying glass in his left hand hovering over his paintbrush, so he could add all the tiny little details to his masterpieces.

Each Mars Attacks illustration began as a pencil sketch by Bob Powell. They were very detailed, very finished, and Dad would paint directly on top of them in gouache. Dad had a story about how he came to paint in gouache. The very first staff art job he ever had, back in the 1920s in Minneapolis, was with Fawcett Publications, which published *Captain Billy's Whiz Bang*, a humor magazine that had bought a few of Dad's cartoons. During the interview, Captain Billy, who ran the place, asked if Dad knew how to paint in "goo-wash." "Oh, sure, of course. Done it a million times!" my father said, and he got the job. As soon as he was out the door, Dad made a beeline to the library and had a hell of a time looking up what "goo-wash" was, having no idea how to spell it. It was one of the most enduring and enriching lessons my father ever taught me: If someone asks if you know how to do something, lie. Dad got a lot of assignments and learned a lot of new things by following that maxim, and so have I.

Dad would sit at his table, unwrap Powell's sketch, and start painting. He was a fast painter,

Pre-Mars Attacks, circa 1958 to 1962, a young Zina Saunders poses with her father, Norm, in his studio. Zina recalls, "For many of Dad's assignments he would take photos of my mother and himself, posing in costume, as photo reference, setting up his Polaroid on a tripod using a timer. Sometimes I would join in."

and he counseled me never to let an art director know how fast you are—they won't pay you as much if they know you do the painting in half the time they think it takes you.

He'd paint glaring Martians sending their minions into battle, snatching moist young women from their beds, and siccing mammoth murderous bugs on our hapless world to crunch us up and spit us out. One of my favorite paintings was of a Martian burning the fur and flesh off a dog in front of a little boy on a sunny suburban street. In the original painting, there was only a skeleton left leaping in the air, but Topps sent the art back with the admonition that it was too gruesome. All along, dad had been grinding out Mars Attacks image after Mars Attacks image depicting Martians eviscerating humans as horrifyingly as they could. But a doggy? Never! So Dad painted the flesh and fur back on so that kiddies could sleep with images of frying dogs—frying, but properly furred!—dancing in their heads. America's children have Joel Shorin, president of Topps and guardian of young, impressionable minds, to thank for that gallant decision!

But Dad did not work alone on Mars Attacks. Unbeknownst to Norm Saunders,

veteran of a thousand covers for pulp magazines and paperback books, he had a secret helper in the form of his nine-year-old daughter, Zina—me. I would wait for Dad to leave his drawing table for the day, and carefully review his work. It was always nearly flawless, to my expert, albeit exceedingly young, eye—but note the "nearly." I always found that the length and density of the eyelashes on the women my father drew fell sadly short of what I knew to be the properly glamorous shape and size of a B-movie girl's lashes. So I would "fix" them, adding my own swipes of black paint to their eyelids. "Ah! Now, *that's* eyelashes!" I would say to myself, before carefully washing out the brush and replacing it where he had left it.

When I asked my father, years later when I was in my twenties, if he was aware that I used to revise and improve his Mars Attacks paintings, he said, "Of course I did—I'd just paint it out and fix 'em back up."

So he said. But when I look carefully—really, really carefully—at those women being mauled by the lusty Martians my father painted fifty years ago, I swear their eyelashes have a suspiciously Zina flare.

SEE FLYING SAUCERS DESTROY EARTH'S LARGEST CITIES!

SEE GIANT INSECTS CRUSH EVERYTHING IN THEIR PATH!

SEE EARTH'S ARMIES ON MARS FIGHTING AGAINST SUPER-WEAPONS!

COLLECT THE ENTIRE SET OF 55 MARS ATTACKS CARDS

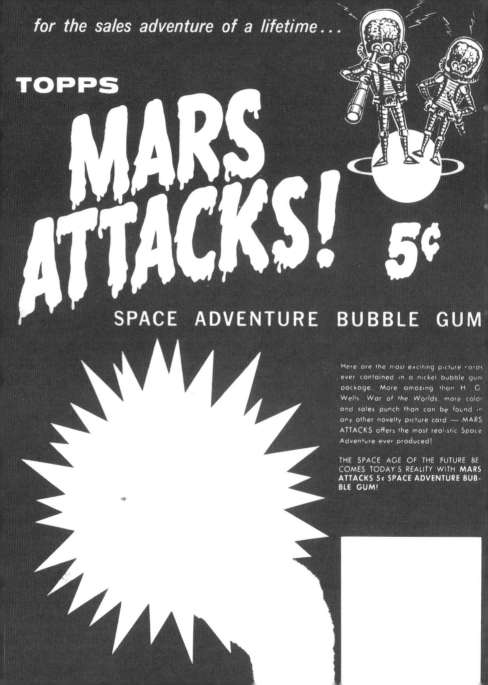